Cover:
FREDERIC REMINGTON (1861-1909)
23. Halt—Dismount! (Detail)

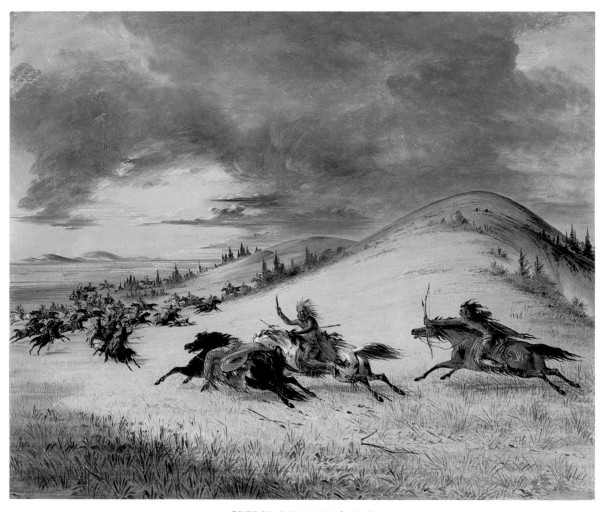

GEORGE CATLIN (1796-1872)
4. Battle Between Sioux and Sauk and Fox, Eastern Dakota

A Festival of
Western American Art
at
Hirschl and Adler

October 12–November 17, 1984

Hirschl & Adler Galleries, Inc.
21 East 70th Street, New York, N.Y. 10021

ACKNOWLEDGEMENTS

A *Festival of Western American Art at Hirschl &
Adler* is the first exhibition ever organized by
Hirschl & Adler devoted exclusively to the art of
the American West. Including, as it does, more
than 160 works, the catalogue that accompanies it
has been the result of the efforts of several
members of the Hirschl & Adler staff. I would
especially like to thank Susan E. Menconi, Douglas
Dreishpoon, Meredith Ward, Sandra K. Feldman,
and Marissa Boyescu for their keen devotion in
producing a catalogue that so vividly depicts the
excellent quality and broad range of the material
included. As always, Françoise Boas has taken
a slew of typewritten sheets and colored
transparencies and transformed them into a
handsome catalogue that once again defied all
schedules and deadlines.

S. P. F.

INTRODUCTION

A *Festival of Western American Art at Hirschl & Adler* is actually a trilogy of exhibitions organized to celebrate the publication by Doubleday and Co. of a facsimile edition of George Catlin's "Album Unique," formerly in the collection of the Duke of Portland.

The first of the three exhibitions is indeed a selection of one-hundred drawings from the Duke's "Album," drawings which have never previously been framed, exhibited, or published. Although ten other albums of this type have been preserved in museum collections across the country, this is the first time that individual drawings and groups of drawings from this important genre of Catlin's work have been available to other institutions and private collectors. Catlin documented fifty tribes in the Duke's "Album," and portraits from all fifty tribes are included in this selection. Each drawing is accompanied by text written by the artist, whose on-the-spot observations reveal his acute sensitivity to his subjects and a prophetic awareness that already by the middle of the nineteenth century whole tribes were disappearing. Important chiefs, and often-times their wives and children, are depicted in great detail, with their costumes, their weapons, and their hunting equipment rendered with remarkable exactitude.

Among the most comprehensive early printed and illustrated works on the American Indian is McKenney and Hall's *History of the American Tribes of North America* of 1837-44, which documents well over one-hundred important American Indians of the day. The publishers, fearing that they might not have access over an extended period of time to portraits of the Indians to be included in their monumental work, commissioned the gifted portrait painter Henry Inman to replicate them. Thirty-one portraits by Inman from this group constitute the second part of this exhibition.

The third part of the exhibition is more broadly based and is comprised of thirty-one paintings, watercolors, and sculptures that depict the American Indian and the American West with a sense of dignity and grandeur that was soon to disappear as the Indians were displaced to reservations, their unique way of life vanishing forever. George Caleb Bingham's *The Concealed Enemy*, Frederic Remington's *Halt-Dismount!*, and Thomas Moran's *Hot Springs of Gardiners River, Yellowstone National Park, Wyoming Territory* each depict a vastly different time and place. They share among themselves, however, and with the other works in this exhibition by Seth Eastman, Alfred Jacob Miller, William Jacob Hays, Sr., Albert Bierstadt, and Henry Farny, among others, a brilliant artistic understanding of the American Indian and the western American landscape before the spread of "civilization" decreed that neither the actors nor the setting for the great American western drama would ever be the same again.

September 3, 1984 Stuart P. Feld

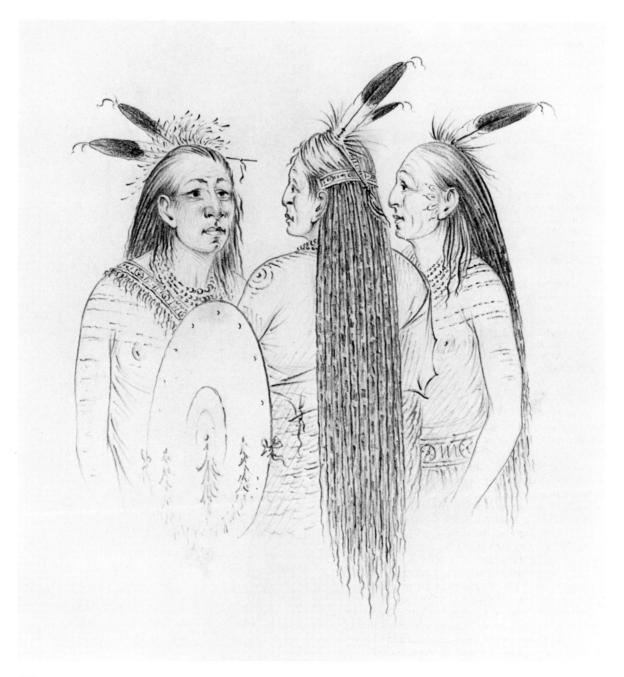

112

Mandan

*San-ja-ka-ko-ka. (the Deceiving Wolf) a
noted Warrior, with his shield on his arm, in a
group with two other young men, names not
known.*

*These three portraits well illustrate the peculiar
mode of drefsing and wearing the hair,
practiced by the Mandans. The hair of the
young men generally falls to the haunches or
calves of the legs, and is invariably divided into
flat slabs, and filled, at intervals of two or three
inches, with glue and red or yellow ochre.*

GEORGE CATLIN (1796-1872)

1. Duke of Portland "Album Unique"

In a letter from George Catlin to the Duke of Portland, dated May 31, 1859, Catlin offered to sell his "Album Unique" with the following qualifications:

> I have the liberty of sending for your inspection, what no other person on earth can send you: two volumes of portraits of N. Am. Indians, illustrating all the tribes in N. America, both in British and United States Territories.

> This collection is entirely the work of my own hand, and contains all the portraits which were seen in my collection at the Egyptian Hall, with the other tribes on the Pacific coast, which I have visited at great expense, and with great fatigue, during the last 3 years, and which will be found to be of curious interest.

> These drawings were reduced from my original paintings with the greatest care, with the view of publishing in that form, but which plan I have abandoned. And if your Lordship should feel disposed to possess and perpetuate these Records of those abused and fast vanishing Races, whose looks and customs I have devoted the best part of my life, and all my means, in rescuing from oblivion, I know of no one into whose hands I should feel more satisfied to place them ...

The Duke of Portland (probably William John Cavendish Bentinch-Scott, 1800-1879) bought Catlin's album for the moderate price of 75 pounds. By 1859, Catlin was 63 years old and had been painting and drawing North American Indians since the 1820's. Although he had, by this time, amassed an extensive collection of painted portraits, genre scenes, and Indian paraphernalia, and had established a notable reputation in Europe and America, he continued to encounter difficulties selling his work to private patrons, or bequeathing his *Indian Gallery* to public institutions. Always pragmatic, however, Catlin recognized the importance of reproducing his *Indian Gallery* for a larger commercial market. By 1840—the year of his European debut at London's Egyptian Hall—his *Indian Gallery* already included 507 paintings, and in 1844 he executed the first *North American Indian Portfolio,* a set of twenty-five chromolithographs based on popular images from his Indian collection. Seen in this way, Catlin's "Albums Unique," or "Souvenir Albums" were a further extension of his desire to have his work selectively reproduced.

The forerunner to the Souvenir Albums appears to be an album dated 1849, commissioned by or sold to Sir Thomas Phillipps, and today housed at the Thomas Gilcrease Institute of American History and Art, Tulsa, Oklahoma. This album, which consists of fifty pencil drawings heightened with watercolor, has a title page that reads, "Souvenir of the North American Indians as They Were in the Middle of the Nineteenth Century." Shortly after the Gilcrease album, Catlin began to execute other Souvenir Albums, each inscribed with a similar title page and each composed of portraits based on his original *Indian Gallery.* The Duke of Portland's portfolio is one of eleven Souvenir Albums executed between 1852 and 1868. Scattered throughout the United States and Europe, these are presently in the manuscript

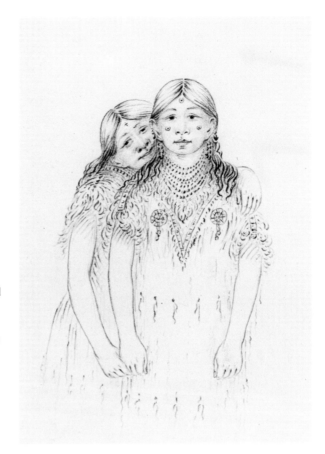

56

Camanchee

(_____)

(_____) Two Camanchee children, daughters of the Chief (n⁰ 51)

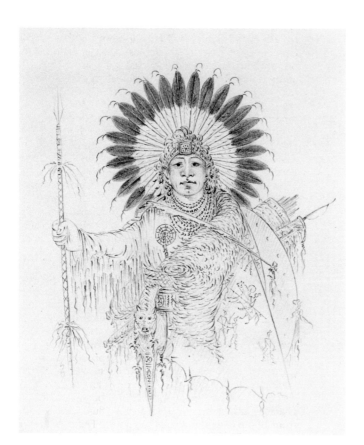

121

Crow

Ba-da-ah-chon-du (he who jumps over everyone) Chief of a Band, in a wonderful costume; Shield and quiver slung, his lance in his hand, and his head drefs of War Eagles quills.

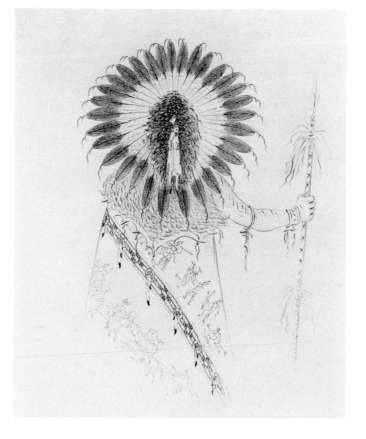

122

Crow

Ba-da-ah-chon-du (he who jumps over every one)
Same as on the foregoing page.
 The portrait of this proud and vain man being finished, he "took a good look at it," and declared himself very well pleased with what he could see of himself; but he was evidently disappointed and dejected, because he could not see the hinder part of his beautiful drefs at the same time. The difficulty of doing this in a portrait was explained to him, and the only way to remedy it, by making a second picture, for which he stood, with great patience, and became perfectly satisfied.

collections of the British Museum, London, England; Henry E. Huntington Library, San Marino, California; Heye Foundation, Huntington Free Library and Reading Room, Bronx, New York; Montana Historical Society, Helena, Montana; The New-York Historical Society; The New York Public Library; New York State Library, Albany; Newberry Library, Chicago, Illinois; Stark Museum of Art, Orange, Texas; and the Beinecke Rare Book and Manuscript Library, Yale University, New Haven, Connecticut.

While Catlin's descriptive title "Album Unique" is somewhat misleading, given the frequency with which individual portraits and descriptive information reappear in successive albums, each album does vary subtly in design and execution. The most notable variations are two portfolios in the collections of The New York Public Library and The New-York Historical Society. In both sets, dated 1850 by Catlin but probably executed later than their counterparts, Catlin enlarged the format of his album. He included on a single folio sheet as many as five Indians and sketched in background scenery, additional figures, and local accoutrements. These "Outlines" are the most ambitious of the Souvenir Albums, and are a synthesis of the latter. While the format of the "Outlines" and Souvenir Albums varies, in both Catlin consistently included, on a separate sheet, descriptive information written in his own hand to complement each individual or group of portraits. He was methodical in his presentation of information. Descriptions list the name of an individual, his tribe, the number of members and geographical location of the tribe, and, in certain cases, an anecdotal supplement. A tribe's geographical location is cited by its proximity to major settlements or rivers and by its latitudinal coordinates. In the Duke of Portland's album, Catlin represented fifty tribes, based, for the most part, on his original *Indian Gallery*. From each tribe he selected its most important members—chiefs and their heirs, warriors, shamen, and squaws—who, in turn, became the central core of his Indian collection.

In its physical dimensions and stylistic execution, the Duke of Portland's album is similar to Souvenir Albums in the Newberry, Beinecke, and Albany Libraries. Unlike their folio counterparts at The New York Public Library

and The New-York Historical Society, each of these smaller format albums has a preciousness underscored by its intimate scale. These albums were not intended to be viewed as Indian picture books, but as proto-anthropological texts. Each portrait enhances the text but functions equally as an independent drawing. In considering each of his albums "unique," Catlin was very aware of the slightest variations within each set. When comparing the Duke of Portland's album with its companions, such variations are noteworthy. The number of portraits per album varies: 215 in the Duke of Portland's album; 99 in the Beinecke; 217 in the Newberry; and 100 in the Albany album. In each album Catlin varied the descriptive information that accompanied each portrait. While the basic information remains consistent from one album to the next, the general word order is often changed. This is also true of the preface or "Remarks" that follow the title page of each album. Here, Catlin added phrases or a single word to enhance the individual character of each album. Stylistically, Catlin varied the degree of definition and articulation within specific passages of each portrait. In the Duke of Portland's album, facial features are highly modeled, while, for example, in the Newberry album, these are by and large left inarticulated. By varying his sitter's presentation (half or full-length; profile or three-quarter; seated or upright), and such details as facial markings, decorative motifs on drapery, and the size and shape of eyes, ears, and noses, Catlin subtly affected the character and personality of each individual portrait from album to album. In this respect the Duke of Portland's album is particularly distinguished; the treatment of details and specific passages is consistently refined and carefully handled.

Of the 215 drawings in the *Duke of Portland "Album Unique,"* Hirschl & Adler Galleries is pleased to exhibit a large selection of them. Each drawing, executed in pencil on paper and measuring $14 \times 10\frac{1}{2}$ inches, bears a number given to it by Catlin and a description of the sitter in the artist's own hand. The works illustrated here include both the number and the accompanying text in Catlin's original spelling. A facsimile of the entire album, published by Doubleday and Co., New York (1984), is also available.

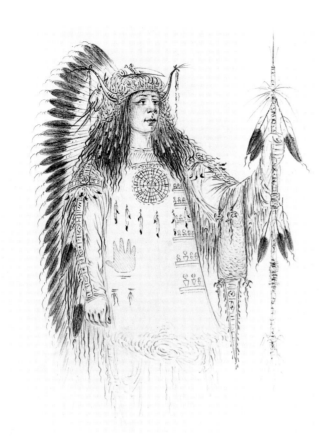

108

Mandan

Mah-to-toh-pa (the Four Bears) War Chief of the Mandan Tribe. one of the most celebrated chiefs known to have existed amongst the American tribes in a very splendid costume, trimmed with Ermine and Scalp locks. His head drefs, made of Ermine and War Eagles quills, descends to the ground and is Surmounted with horns, denoting his power, or authority as head War Chief of the tribe.

 a Small tribe of 2000. W. bank of Mifsouri 2000 miles above St. Louis. This tribe was almost entirely destroyed by Small pox the next year after the Author visited it.

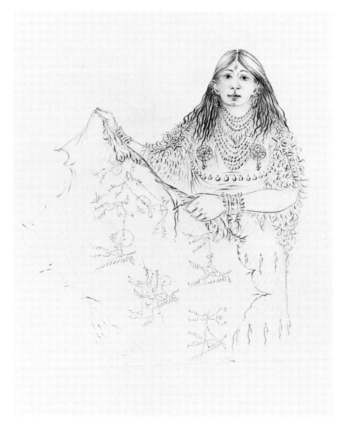

109

Mandan

Mi-neek-e-sunk-te-cah (the Mink) the young (and favorite) wife of the War Chief on the foregoing page, in a beautiful drefs of mountain sheepskins, and holding up to view, the Robe of her husband, with all the battles of his extra ordinary life, painted on it.

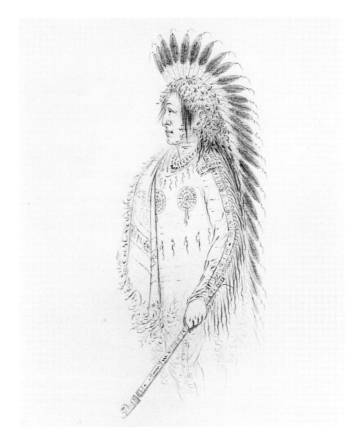

Assinneboin

Wi-jun-jon (The Pigeons Egghead) a celebrated young man, and son of the chief of the tribe, <u>on his way to Washington</u>, where he and the chiefs of several other of the remotest tribes had been invited by the President of the U. States, and where they were being conducted by Maj-Sanford, the Gov^t Indian Agent for those Tribes. This portrait was painted in Saint Louis, when the party were en route for Washington, and all in their beautiful and graceful, native costumes.

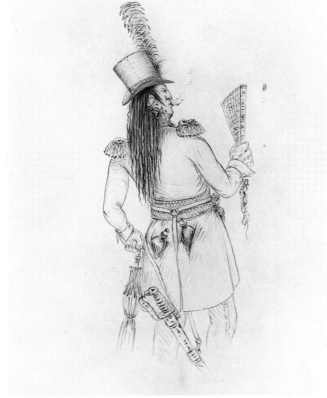

215

Assinneboin

Wi-jun-jon (the Pigeon's Egg Head) portrait of the same young man represented on the foregoing page, painted 18. months afterwards, <u>on his way back from Washington</u>, towards his native village in the wildernefs, to which the author accompanied him and his companions, a distance of 3.500. miles, and saw them enter their villages and meet their friends, and wives and children, in the costumes here represented, presented to them by the President of the U. States, their native drefses and equipments being left amongst Indian Curiosities in the War department at Washington.

<div align="right">

Geo-Catlin.
London. 1852.

</div>

HENRY INMAN (1801-1846)

2. The McKenney and Hall Collection of Portraits of American Indians

Representing one of the finest artistic and anthropological records of the native American, *The McKenney and Hall Collection of Portraits of American Indians* was created because of the vision of one man, Thomas L. McKenney, an ardent supporter of Indian culture. By 1820, McKenney, then United States Superintendent of Indian Trade, had conceived of establishing in Washington, D.C., a national collection of Indian artifacts and records. Various delegations of Indian tribes were continually visiting the nation's capitol during the 1820's, often to negotiate treaties or voice tribal complaints, and McKenney met with many of the visitors. He took these opportunities not only to collect memorabilia from them, but also to have their portraits painted by Charles Bird King for a government-sponsored Indian picture gallery. By 1830, King had painted over one-hundred portraits from life, including depictions of leaders from such well-known tribes as the Cherokee and Seminole from the South, the Menominees and Senecas from the Great Lakes area, and the Omahas and Pawnees from the Great Plains territory. The expanding Indian collection was housed in the War Department building (in 1824 McKenney was appointed director of the Bureau of Indian Affairs of the War Department) and attracted an enthusiastic group of visitors, both American and foreign. The group of portraits was recognized as a valuable national resource and was ultimately moved, in 1858, to a specially designed Gallery of Art in the new Smithsonian Institution. There, on January 24, 1865, fire raged through the gallery, completely destroying the collection of Indian portraiture.

Most of this collection is preserved today in the portraits painted by Henry Inman after the originals by Charles Bird King and other artists. The fact that this remarkable group by Inman exists is again due to Thomas McKenney's dedication to the American Indian. He envisioned while still in Washington a grand, several volume publication of artistic and historical merit that would reproduce the C. B. King portraits. However, McKenney, a political supporter of John Calhoun, lost his position at the Bureau of Indian Affairs in 1830 after Andrew Jackson assumed the Presidency. McKenney then moved to Philadelphia, took a job as a newspaper editor, and established a network of friends and financial supporters to assist him in the eventual publication of the *History of the American Indian Tribes of North America.* Through his allies, he was able to retrieve important documentary information about various Indians and

their tribes, information that largely remained in archives McKenney himself had established in Washington. Although he no longer had easy access to the portraits in the Indian gallery, he was able to secure permission to have them sent in small groups to Philadelphia. McKenney commissioned Henry Inman to produce copies of these portraits upon which the colored prints in his ambitious book could be based. By the close of 1833, Inman had finished over seventy-five of these copies, and McKenney was greatly impressed with the results, though various personal and financial setbacks postponed publication of his envisioned book. However, in 1836, James Hall of Cincinnati, Ohio, became McKenney's partner and editor and provided the necessary stimulus for completion. That year, in the hope of attracting potential subscribers, McKenney and Hall's publisher advertised and exhibited the Inman portraits at Masonic Hall, Chestnut Street, Philadelphia, alongside several sample lithographs for the book. Between 1837 and 1844, three volumes of the *History of the American Tribes of North America* were published, containing reproductions of a large portion of the Inman portraits. It is probable that a fourth volume was originally planned and would have included the remaining works in the group. The volumes published in 1837 and 1838 met with great critical and financial success, and, because of this, McKenney even spoke of touring the Inman paintings in Europe and selling them there for fabulous sums. This notion was never realized and, due to financial pressures following the panic of 1837, the entire group of Inman portraits was submitted to the Boston paper firm of Tileston and Hollingsworth in settlement of debts. The collection remained in the possession of that company until 1882, at which time it was donated to the museum of an academic institution.

The McKenney and Hall Collection consists of 109 portraits, of which approximately half have already been placed in museums and historical institutions across the United States. Based upon substantial documentation, all paintings are assumed to be by Henry Inman (1801-1846) after the now-lost originals by Charles Bird King (1785-1862), unless otherwise described. Each portrait is painted in oil on canvas, measures 30 × 25 inches, and most retain their original flat Greek Revival frame, painted to suggest wood graining. The three-volume McKenney and Hall *History of the American Indian Tribes of North America,* first published between 1837 and 1844 and containing two-thirds of the Inman portraits, has been reproduced in James D. Horan, *The McKenney-Hall Portrait Gallery of American Indians* (1972), hereafter abbreviated as Horan. An asterisk denotes portraits which are on view in the exhibition.

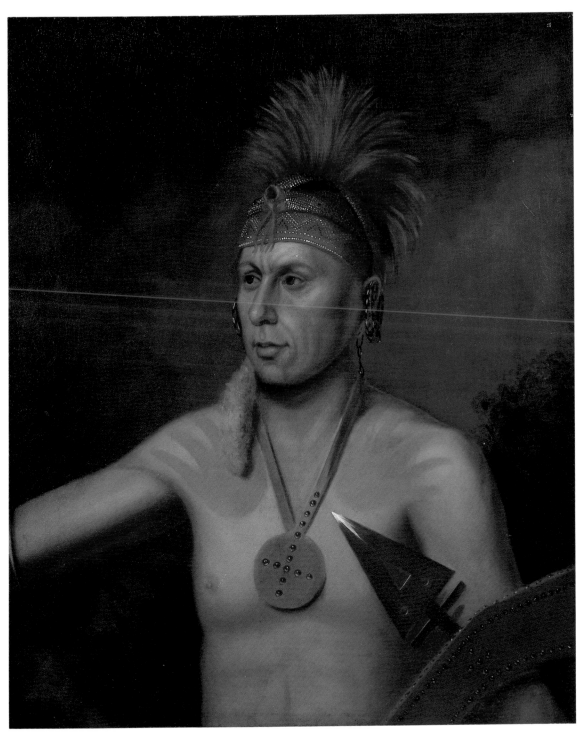

2-41. Keokuk, Chief of the Sauk and Fox Nation

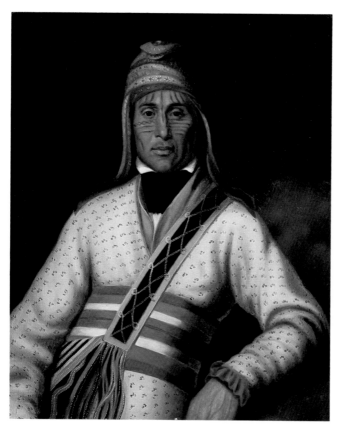

2-8. Yoholo-Micco, A Creek Chief

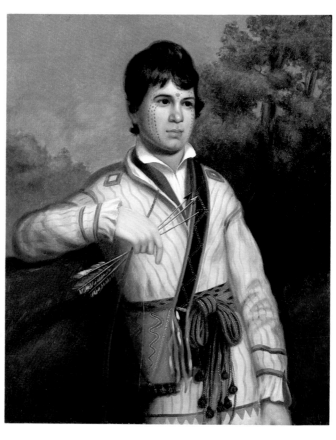

2-4. Mistippee, son of Yoholo-Micco

TRIBE CHEROKEE (Family Iroquoian)

2-1. **Ta-Go-Nis-Co-Te-Yek** or **Black Fox,** A Cherokee Chief

*2-2. **Too-An-Tuh** or **Spring Frog**
RECORDED: Horan, pp. 276-78 illus. in color

TRIBE CREEK (Family Muskhogean)

*2-3. **Me-Na-Wha** or **The Great Warrior** or **The Crazy War Hunter,** A Creek Chief
RECORDED: Horan, pp. 132-33 illus. in color

*2-4. **Mistippee,** son of Yoholo-Micco
RECORDED: Horan, pp. 140-41 illus. in color

2-5. **Opothle-Yoholo,** A Creek Chief
RECORDED: Horan, pp. 142-43 illus. in color

*2-6. **Paddy Carr**
RECORDED: Horan, pp. 136-37 illus. in color

*2-7. **Selocta**
RECORDED: Horan, pp. 130-31 illus. in color

*2-8. **Yoholo-Micco,** A Creek Chief
RECORDED: Horan, pp. 138-39 illus. in color

TRIBE IOWA (Family Siouan)

*2-9. **Rant-Che-Wai-Me** or **Flying Pigeon**
RECORDED: Horan, pp. 304-05 illus. in color

TRIBE KANSA (Family Siouan)

*2-10. **Monchonsia,** A Kansa Chief
RECORDED: Horan, pp. 340-41 illus. in color

TRIBE MENOMINEE (Family Algonquian)

2-11. **Mar-Ko-Me-Te** or **Bear's Oil**
RECORDED: Horan, pp. 352-53 illus. in color

TRIBE OJIBWA [Chippewa] (Family Algonquian)

2-12. After James Otto Lewis
At-Te-Conse or **Young Rein Deer,** A Chippewa Chief

*2-13. After James Otto Lewis, 1827, copied in Washington, D.C., by C. B. King
Caa-Tou-See
RECORDED: Horan, pp. 226-27 illus. in color

2-14. After James Otto Lewis, 1826, copied by Inman in the 1830's
Chippewa Mother and Child
RECORDED: Horan, pp. 236-37 illus. in color

*2-15. After James Otto Lewis, 1826, copied in Washington, D.C., by C. B. King
Chippewa Squaw and Child
RECORDED: Horan, pp. 232-33 illus. in color

*2-16. **Figured Stone**

*2-17. Probably after James Otto Lewis
I-Aw-Beance

2-18. After James Otto Lewis, 1826, copied in Washington, D.C., by C. B. King
Jack-O-Pa or **The Six,** A Chippewa Chief
RECORDED: Horan, pp. 210-11 illus. in color

*2-19. After James Otto Lewis, 1826, copied in Washington, D.C., by C. B. King
Ka-Ta-Wa-Be-Da or **Old Tooth** or **Broken Tooth,** A Chippewa Chief
RECORDED: Horan, pp. 218-19 illus. in color

2-20. After James Otto Lewis, copied in Washington, D.C., by C. B. King
Kit-Chee-Waa-Be-Shas

2-21. After James Otto Lewis, 1826, copied in Washington, D.C., by C. B. King
Meta-Koosega or **Pure Tobacco**
RECORDED: Horan, pp. 200-01 illus. in color

2-22. After James Otto Lewis, 1827
Mish-Sha-Quat or **Clear Sky,** A Chippewa Chief

2-23. After James Otto Lewis, copied in Washington, D.C., by C. B. King
Naa-Gar-Ness

2-24. North Wind

2-25. After James Otto Lewis, 1826, copied in Washington, D.C., by C. B. King
O-Hya-Wa-Mince-Kee or **Yellow Thunder**
RECORDED: Horan, pp. 204-05 illus. in color

2-26. Ojibwa Chief

2-27. Ojibwa Man

2-28. Ojibwa Man

2-29. After James Otto Lewis
Pe-A-Jick

2-30. After James Otto Lewis, 1826, copied in Washington, D.C., by C. B. King
Pee-Chi-Kir or **Peechekor** or **Buffalo**
RECORDED: Horan, pp. 206-07 illus. in color

*2-31. After James Otto Lewis, 1826, copied in Washington, D.C., by C. B. King
Shin-Ga-Ba-Wosin or **Image Stone**
RECORDED: Horan, pp. 202-03 illus. in color

*2-32. After James Otto Lewis, 1826, copied in Washington, D.C., by C. B. King
Waa-Top-E-Not or **The Eagle's Bill,** A Fox Chief
RECORDED: Horan, pp. 208-09 illus. in color

*2-33. After James Otto Lewis, 1826, copied in Washington, D.C., by C. B. King
Wa-Em-Boesh-Ka, A Chippewa Chief
RECORDED: Horan, pp. 222-23 illus. in color

*2-34. After James Otto Lewis, 1825, copied in Washington, D.C., by C. B. King
Wesh-Cubb or **The Sweet**
RECORDED: Horan, pp. 198-99 illus. in color

2-35. After James Otto Lewis, copied in Washington, D.C., by C. B. King
Wet Mouth

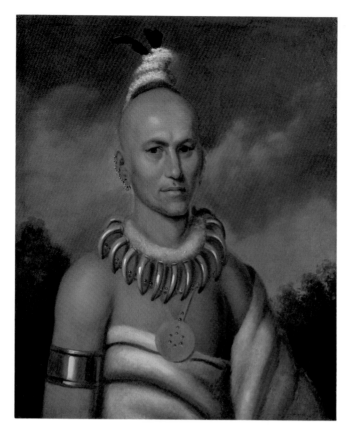

2-44. Tai-O-Mah

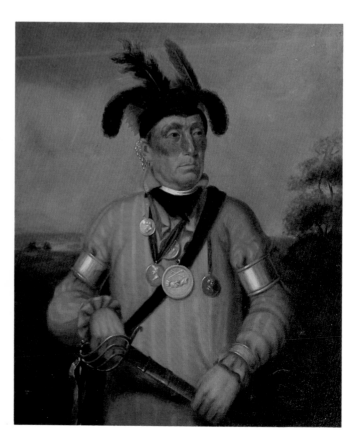

2-50. Mo-Nee-Kaw

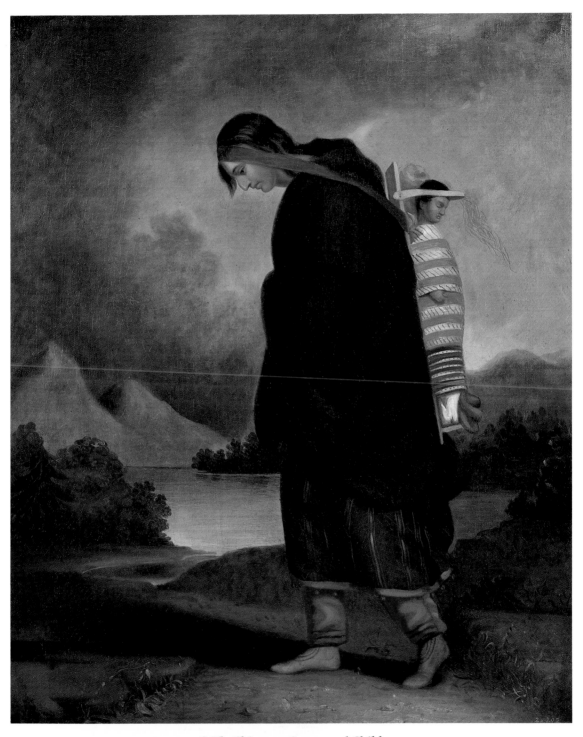

2-15. Chippewa Squaw and Child

TRIBE OTO (Family Siouan)

***2-36. Chon-Ca-Pe** or **The Big Kaw** or **Big Kansas,**
An Oto Chief
RECORDED: Horan, pp. 298-99 illus. in color

TRIBE OTTAWA (Family Algonquian)

2-37. Bass Otis
Ka-Na-Pi-Ma

TRIBE SAUK AND FOX (Family Algonquian)

***2-38. Kai-Kee-Kai-Maih**

***2-39. Kee-Me-One,** A Fox Warrior
RECORDED: Horan, p. 359 illus. in color

***2-40. Kee-Shee-Waa** or **The Sun,** a Medicine Man
RECORDED: Horan, pp. 174-75 illus. in color

***2-41. Keokuk,** Chief of the Sauk and Fox Nation

***2-42. Pah-She-Pah-Haw** or **The Stabber**
RECORDED: Horan, pp. 194-95 illus. in color

2-43. After Charles Bird King or George Cooke
Tahcoloquoit, A Sauk and Fox Chief
RECORDED: Horan, pp. 196-97 illus. in color

***2-44. Tai-O-Mah**
RECORDED: Horan, pp. 182-83 illus. in color

***2-45. Wakechai** or **Crouching Eagle**
RECORDED: Horan, pp. 176-77 illus. in color

TRIBE SEMINOLE (Family Muskhogean)

***2-46. Julcee-Mathla,** A Seminole Chief
RECORDED: Horan, pp. 248-49 illus. in color

TRIBE SHAWNEE (Family Algonquian)

***2-47. Qua-Ta-Wa-Pea** or **Colonel Lewis**
RECORDED: Horan, pp. 162-63 illus. in color

TRIBE SIOUX (Family Siouan)

***2-48.** After James Otto Lewis, 1825
A Sioux Chief

TRIBE WINNEBAGO (Family Siouan)

***2-49.** After James Otto Lewis, 1827, copied in Washington, D.C., by C. B. King
A-Mis-Quam or **Wooden Ladle**
RECORDED: Horan, pp. 288-89 illus. in color

***2-50. Mo-Nee-Kaw**

***2-51. Orator**
RECORDED: Horan, pp. 292-93 illus. in color

2-52. After James Otto Lewis
O-Wan-Ich-Koh or **Little Elk**

2-53. After James Otto Lewis
Wadt-He-Doo-Kaana

2-54. After James Otto Lewis, 1826, copied in Washington, D.C., by C. B. King
Wa-Kawn or **The Snake,** A Winnebago Chief
RECORDED: Horan, pp. 284-85 illus. in color

UNIDENTIFIED TRIBES

2-55. Unknown

2-56. Unknown

2-57. Unknown

2-58. Unknown

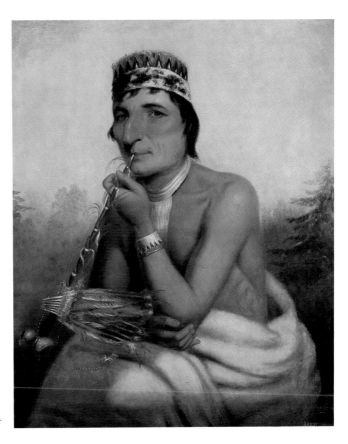

2-33. Wa-Em-Boesh-Ka, A Chippewa Chief

2-48. A Sioux Chief

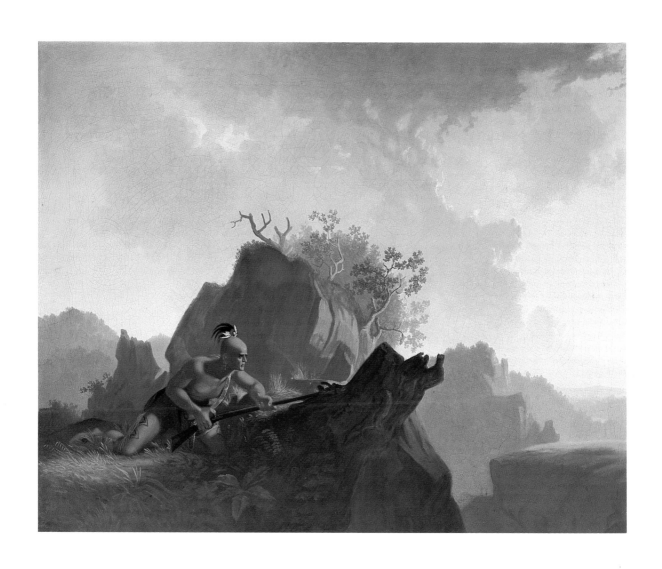

GEORGE CALEB BINGHAM (1811-1879)

3. The Concealed Enemy

Oil on canvas, 29¼ × 36½ in.

Painted in 1845

RECORDED: American Art-Union, *Transactions* (1845), no. 95 // [Meeting of the Committee], American Art-Union (unpub. "Minutes," The New-York Historical Society, New York, Dec. 8, 1845), as *Indian Figure—Concealed Enemy* // Fern Helen Rusk, *George Caleb Bingham: The Missouri Artist* (1917), pp. 33, 120 // Mary Bartlett Cowdrey, *American Academy of Fine Arts and American Art Union: Exhibition Record 1816-1852* (1953), p. 21 // Lew Larkin, *Bingham: Fighting Artist* (1954), p. 63 // John Francis McDermott, "George Caleb Bingham and the American Art-Union," in *The New-York Historical Society Quarterly,* XLII (Jan. 1958), pp. 61-62, 67 illus. // John Francis McDermott, *George Caleb Bingham: River Portraitist* (1959), pp. 53, 216 no. 25 illus., 413 // Albert TenEyck Gardner and Stuart P. Feld, *American Paintings: A Catalogue of the Collection of The Metropolitan Museum of Art,* I (1965), p. 251 // E. Maurice Bloch, *George Caleb Bingham: The Evolution of an Artist* (1967), pp. 110-12, 256, [n.p.] pl. 75 // E. Maurice Bloch, *George Caleb Bingham: A Catalogue Raisonné* (1967), p. 53 no. 137 // Albert Christ-Janer, *George Caleb Bingham: Frontier Painter of Missouri* (1975), [n.p.] colorpl. 162 // Henry Adams, "A New Interpretation of Bingham's *Fur Traders Descending the Missouri,*" in *The Art Bulletin,* LXV (Dec. 1983), pp. 675-80, 676 fig. 1

EXHIBITED: American Art-Union, New York, 1845, no. 95 // Joslyn Art Museum, Omaha, Nebraska, 1954, *Life on the Prairie, the Artist's Record,* p. 5 [n.n.] // City Art Museum, St. Louis, Missouri, and Walker Art Center, Minneapolis, Minnesota, 1954-55, *Westward the Way,* pp. 73, 115 no. 82 illus., 265 // William Rockhill Nelson Gallery of Art, Mary Atkins Museum of Fine Arts, Kansas City, Missouri, and City Art Museum of St. Louis, Missouri, 1961, *George Caleb Bingham: Sesquicentennial Exhibition 1811-1961,* [n.p.] no. 5 // National Collection of Fine Arts, Washington, D.C., The Cleveland Museum of Art, Ohio, and The Art Galleries, University of California at Los Angeles, 1967-68, *George Caleb Bingham 1811-1879,* pp. 39-40, 90 no. 11 // Hirschl & Adler Galleries, New York, 1968, *The American Vision: Painting 1825-75,* [n.p.] no. 51 illus. // Whitney Museum of American Art, New York, 1973, *The American Frontier: Images and Myths,* p. 59 no. 5 // William Rockhill Nelson Gallery of Art, Mary Atkins Museum of Fine Arts, Kansas City, Missouri, 1977-78, *Kaleidoscope of American Painting: Eighteenth and Nineteenth Centuries,* p. 30 no. 32 illus. // Hirschl & Adler Galleries, New York, 1984, *The Art of Collecting,* pp. 16-17 no. 8 illus. in color

EX COLL: Submitted by the artist in 1845 to the American Art-Union, New York, for sale; purchased by the American Art-Union on Dec. 8, 1845, for $40.00; awarded Dec. 19, 1845, to James A. Hutchison, Pittsburgh, Pennsylvania; David Ives Bushnell, Jr., Washington, D.C., until 1946; by gift to the Peabody Museum of Archaeology and Ethnology, Harvard University, Cambridge, Massachusetts

George Caleb Bingham's best known works depict the life of local boatmen, fur traders, fishermen, and politicians along the Mississippi and Missouri Rivers. Working at the edge of what was then the western frontier, he also recorded another aspect of life there, that of the American Indian. Only two paintings of this subject are currently known, the present work of 1845 and *Captured by Indians* (or *The Captive*) of 1848 (The St. Louis Art Museum, Missouri).

The Concealed Enemy and *Fur Traders Descending the Missouri* (The Metropolitan Museum of Art, New York), also of 1845, are two of Bingham's earliest genre scenes and among the first pictures he submitted to the American Art-Union, New York. According to E. Maurice Bloch in *George Caleb Bingham: The Evolution of an Artist* (1967), p. 111, *The Concealed Enemy,* "suggests the tension of the moment just preceding an action and indicates more of the imaginative story-telling aspect than is usual with Bingham."

Henry Adams, Curator, Nelson-Atkins Museum of Art, Kansas City, Missouri, has recently advanced the theory [*loc. cit.*] that this picture and *Fur Traders Descending the Missouri* were originally conceived as pendants, with the former expressing Indian "savagery" and the latter, emerging American civilization.

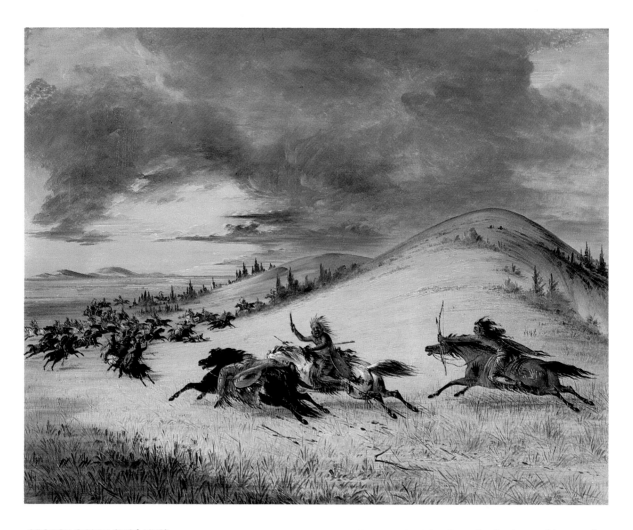

GEORGE CATLIN (1796-1872)

4. Battle Between Sioux and Sauk and Fox, Eastern Dakota

Oil on canvas, 25¾ × 32 in.

Painted about 1846-48

RECORDED: *cf.* William Truettner, *The Natural Man Observed: A Study of Catlin's Indian Gallery* (1979), p. 300 no. 545 illus.

EX COLL: [sale, Sotheby's, New York, Oct. 17, 1980, *American 18th Century, 19th Century & Western Paintings, Drawings, Watercolors & Sculpture,* (n.p.) no. 16 illus. in color]; to private collection, until 1984

This picture is nearly identical in size and composition to a work of the same title in the collection of the National Museum of American Art, Washington, D.C., which is very close stylistically to a series of works Catlin painted for Louis Philippe of France between 1846 and 1848 [*cf.* Truettner, *loc. cit.*]. Probably painted during this same period, when Catlin was living in Paris, the picture is a variation on one of a group of paintings that Catlin produced in response to what Truettner calls "a European preference for 'Wild West' scenes over studies of Indian life."

Catlin described the fierce battle depicted here in his 1848 catalogue of his collection: "The Sioux chief killed and scalped on his horse's back. An historical fact."

A less detailed version of this scene, Cartoon 273, is in the collection of the National Museum of American Art, Washington, D.C.

JOSEPH LEE (1780-1859)

5. Ralston Hall and its Grounds, San Mateo County, California

Oil on canvas, 30 × 47⅝ in.

Signed and inscribed (at lower right): Joseph Lee. Painter

Painted about 1855-59

The painting depicts the property situated on the peninsula south of San Francisco in what is today known as Belmont, San Mateo County, California. A Count Cipriani, an Italian emigré, owned the property in the 1850's and early 1860's and built a modest villa there. The property was subsequently purchased from the Count in 1865 by William Chapman Ralston (1826-1875), who made his fortune in the silver mining boom of the 1860's. Ralston, incorporating the villa built by Cipriani, embarked on the construction of an extremely grand eighty-two room home, Ralston Hall, to which he constantly added new and more luxurious features. Overextending himself, he was ruined financially in 1875, and died mysteriously that same year. Senator William Sharon, his partner and closest associate, inherited all Ralston's assets and liabilities, including the Belmont estate. It was later sold to a Mrs. Bull, who made it into a girl's school. Next it became a private sanitarium run by a Dr. Gardiner. In 1922, the Sisters of Notre Dame purchased it and turned it into the College of Notre Dame, a women's liberal arts college, which it is today. The present owners have tried to rehabilitate the interior of the mansion and restore it to its former state.

A painting of this scene, executed at a later date by George Frost, is in the collection of the California Historical Society, San Francisco.

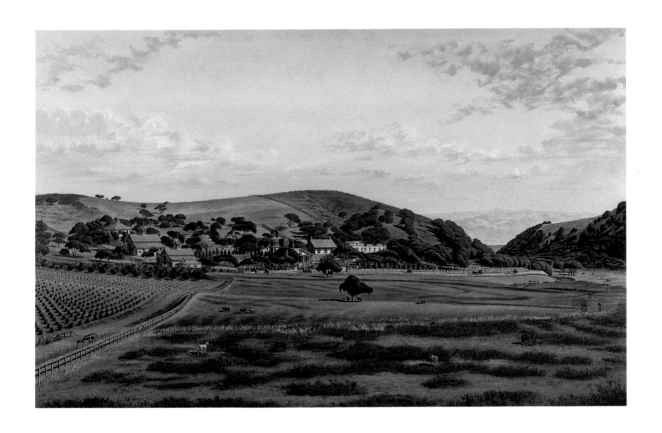

SETH EASTMAN (1808-1875)

6. Chippewa Indians Playing Checkers

Oil on canvas, 30 × 25 in.

Inscribed (at lower left, on barrel head): ⟨S⟩ /Sioux

Painted in 1848

RECORDED: John F. McDermott, *Seth Eastman, Pictorial Historian of the Indian* (1961), pp. 58, 232 no. 53, pl. 1 as frontispiece in color // Wendy J. Shadwell, "Middendorf Collection at the Metropolitan," in *The Art Gallery Magazine,* XI (Oct. 1967), pp. 25 illus. in color, 27 // Shirley Glubock, *The Art of the Old West* (1971), p. 14 illus. // *The Vincent Price Treasury of American Art* (1972), illus. in color // Time-Life Books, ed., *The Gamblers* (1978), p. 16 illus. in color

EXHIBITED: American Art-Union, New York, 1850, no. 155, as *Indians Playing Draughts* // Smithsonian Institution, Washington, D.C., traveling exhibition, 1959-60, *The Art of Seth Eastman,* pp. 11 fig. 3 illus., 12, 29 no. 17, as *Indians Playing Draughts,* lent by M. Knoedler and Company, Inc. // California Palace of the Legion of Honor, San Francisco, 1964, *American Paintings of the Nineteenth Century,* no. 30, as *Indians Playing Draughts,* lent by Victor D. Spark, New York // The Baltimore Museum of Art, Maryland, and The Metropolitan Museum of Art, New York, 1967, *American Paintings and Historical Prints from the Middendorf Collection,* pp. 18-19 no. 19 illus. in color // Hirschl & Adler Galleries, New York, 1968, *The American Vision: Paintings 1825-1875,* [n.p.] no. 55 illus. in color, lent by Mr. and Mrs. J. William Middendorf II // Hirschl & Adler Galleries, New York, 1970, *Forty Masterworks of American Art,* pp. 26-27 no. 15 illus. // Hirschl & Adler Galleries, New York, 1978, *American Genre Painting in the Victorian Era—Winslow Homer, Eastman Johnson, and Their Contemporaries,* p. 19 no. 18 illus. in color

EX COLL: American Art-Union, New York, 1850; distributed to Joseph Murdoch, Roxbury, Massachusetts; John Jayne; [M. Knoedler and Co., New York, and Victor Spark, New York, until 1965]; to Mr. and Mrs. J. William Middendorf II, Greenwich, Connecticut, until 1970; to [Hirschl & Adler Galleries, New York, 1970-72]; to Howard Garfinkel, Miami Beach, Florida; to [Forum Galleries, New York, until 1975]; to [Hirschl & Adler Galleries, New York, 1975]; to Mr. and Mrs. Jack Warner, Tuscaloosa, Alabama, until 1977; to [Hirschl & Adler Galleries, New York, 1977-80]; to private collection, until 1984

As a military career man, Seth Eastman traveled extensively in the western United States on Army assignments. Trained in drawing at the United States Military Academy, West Point, New York, Eastman initially was sent West on topographical surveys, and subsequently returned to West Point as an assistant teacher of drawing under Robert Weir. After 1840, however, when he was assigned to posts in Florida, Minnesota, and Texas, Eastman became increasingly interested in Indian customs. In fact, he even learned to speak the Sioux language.

In 1841, Eastman was ordered to Fort Snelling, Minnesota, where his understanding of the Indians not only made him a more successful officer in settling disputes between tribes, but also enabled him to portray the natives more insightfully in his paintings. An anonymous critic wrote in the *Missouri Republican* (Nov. 30, Dec. 1, 1847): "[Eastman's] position and official status in the Indian country, and frequent contact with them, has enabled him to study minutely their character and peculiarities; and pursuing, for pleasure and amusement, the bent of his tastes, he has been enabled to transfer to the canvas a more animated picture of real Indian life, than any we have ever seen before. . . ."

Eastman's advantageous position for studying the Indian is clearly seen in *Chippewa Indians Playing Checkers,* which was executed during his eight year tenure at Fort Snelling. The casual intimacy of the scene suggests the artist's familiarity with his subject, while the intricate detail of the Indian costumes and objects in the foreground indicate Eastman's unfailing concern with historical documentation.

According to a letter dated June 27, 1849, from the artist's wife Mary to Colonel Andrew Warner, corresponding secretary of the American Art-Union, the scene depicts, "likenesses of two Chippeway [sic] Indians who were kept for a long time in the Guard House at Fort Snelling. They passed away their time playing Cards, Checkers, and Smoking" (American Art-Union Papers, The New-York Historical Society).

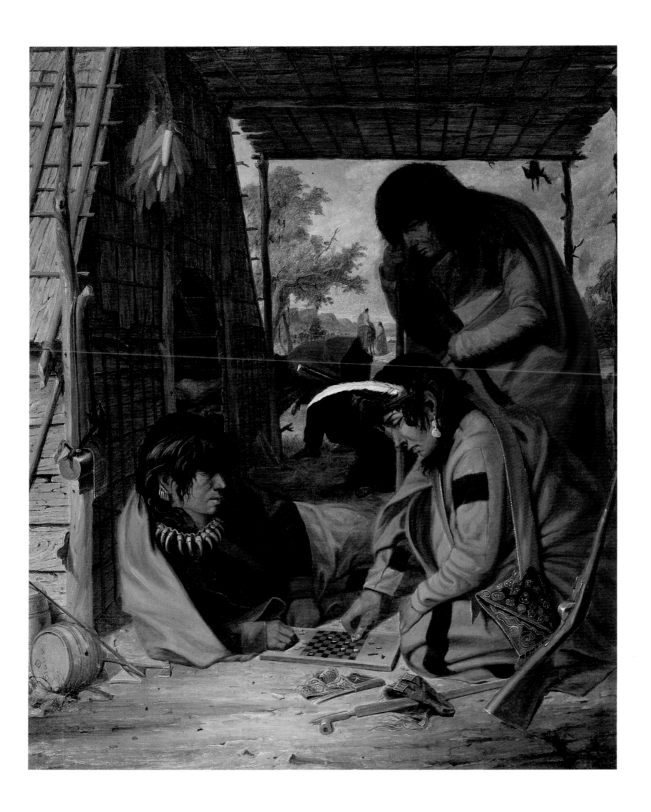

GEORGE CATLIN (1796-1872)

7. Stag and Doe

Oil on canvas, 19 × 26½ in.

Signed (at lower left): Catlin

Painted about 1854

RECORDED: William H. Truettner to M. Knoedler and Co., New York, Oct. 3, 1975 (unpub. letter, M. Knoedler and Co. archives)

EXHIBITED: M. Knoedler and Co., New York, 1972, *19th and 20th Century American Paintings from the Gallery Collection,* p. 6 no. 33 // M. Knoedler and Co., New York, 1972, *George Catlin: A Collection of His Works,* [n.p.] no. 9

EX COLL: the artist; to Leopold I, King of Belgium, in 1859; to Richard Smithill, Rockbeare, Hants, England; [H. Williams, New York, by 1907]; Sir Edmund Osler, Toronto, Canada; by gift to the Royal Ontario Museum, Toronto, 1912-54; to [Lee Pritzker, Toronto, in 1954]; to [Hirschl & Adler Galleries, New York, 1954]; to [M. Knoedler and Co., New York, 1954-74]; to Michael Zinman, Rockport, Maine, 1974-84

According to William H. Truettner, Associate Curator, National Museum of American Art, Washington, D.C. [*loc. cit.*], "the earliest reference to *Stag and Doe* is from a small catalog of Catlin's paintings offered in 1907 by the New York dealer H. Williams." Truettner continued: "The size is given as 27 × 19 inches, and a note in the catalog says that the paintings were exhibited in London in 1859 and then purchased by the King of the Belgiums from Catlin."

The country of Belgium assumed an important role in Catlin's later life. After spending the years 1850 to 1857 traveling around South America, he first went to Brussels in 1857 and returned again in 1860 to spend the next decade there, working out of a small apartment, drawing, painting, and writing, in essence, recollecting and reconstructing his past. According to Truettner, the *Stag and Doe* subject first appeared as a small water-color in an early *Souvenir* album inscribed Egyptian Hall, London, 1849 (Thomas Gilcrease Institute of American History and Art, Tulsa, Oklahoma).

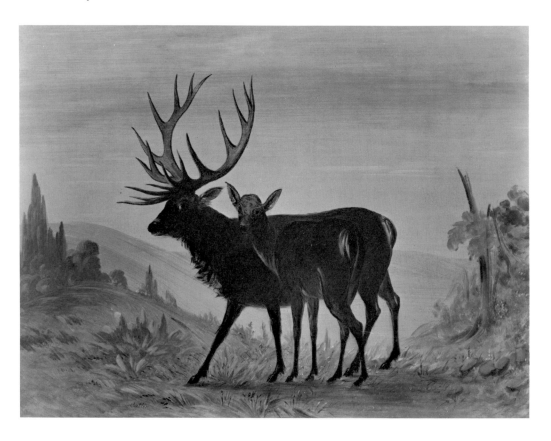

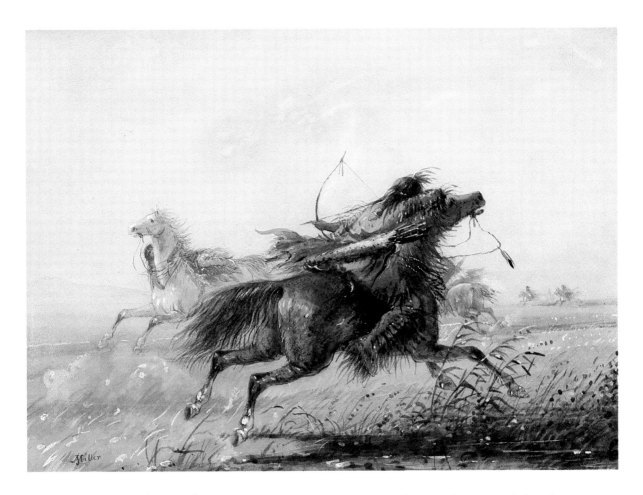

ALFRED JACOB MILLER (1810-1874)

8. Skirmishing—Dodging an Arrow

Watercolor on paper, 8³⁄₁₆ × 11⁷⁄₁₆ in. (sight size)

Signed (at lower left): AJM[monogram]iller

Inscribed (on the back): Skirmishing—Dodging an Arrow/$12.

Executed about 1860-67

RECORDED: cf. Marvin C. Ross, *The West of Alfred Jacob Miller* (1968), p. 134 illus. // Karen Dewees Reynolds and William R. Johnston, *Alfred Jacob Miller: Artist on the Oregon Trail* (1982), p. 330 no. 390B, as *Dodging an Arrow (Crow)*

EXHIBITED: Hirschl & Adler Galleries, New York, 1982-83, *Lines of Different Character—American Art from 1727 to 1947*, p. 41 no. 27 illus. in color, as *Dodging an Arrow (Crow)*

EX COLL. [The Myers & Hedian Art Galleries, Baltimore, Maryland]

This watercolor is similar to one titled *Dodging an Arrow (Crows)* in the collection of The Walters Art Gallery, Baltimore, Maryland. In the notes accompanying the description of that picture [Ross, *loc. cit.*] are Miller's comments: "... In skirmishing on horseback, [the Indian] makes a target of his horse, watching the deadly arrow of his adversary;—he quick as lightning clings to his horse's neck;—dropping his body to the opposite side, exposing but a part of his arm and leg to his enemy,— sometimes he holds on simply by the heel, while the horse is in full motion.

"In such an attitude he will discharge his arrows under the horse's neck, recovering his seat in a moment;—this is only attained by long practice,—a broken neck certainly awaits any one who tries to accomplish the feat for the first time."

JOSEPH MOZIER (1812-1870)

9. Pocahontas

Marble, 48 in. high

Signed, dated, and inscribed (on the base): MOZIER · Sc./ROME.1859

Titled (on the base): POCAHONTAS

10. The Wept of Wish-ton-Wish

Marble, 48 in. high

Signed, dated, and inscribed (on the base): J. MOZIER Sc:/ROME 1859

Titled (on the base): THE WEPT OF WISH·TON·WISH

RECORDED: *cf.* Henry T. Tuckerman, *Book of the Artists* (1867), p. 591 // *cf.* Lorado Taft, *The History of American Sculpture* (1903, revised ed. 1924, reprint 1969), pp. 109-10 // *cf.* William H. Gerdts, *American Neo-Classic Sculpture: The Marble Resurrection* (1973), pp. 42, 120-21 no. 134 illus., 131 no. 156 illus., 142-43 no. 176 detail illus. // Mimi Findlay, "LeGrand Lockwood, Patron of American Expatriot Sculptors," in catalogue to *The Lockwood-Mathews Mansion Antiques Show* (1982), records and illus. these versions pp. 6-7

EXHIBITED: Hirschl & Adler Galleries, New York, 1982, *Carved and Modeled: American Sculpture 1810-1940,* pp. 26-27 nos. 8a and 8b illus.

American neoclassic sculpture of the nineteenth century offered many interpretations of American Indians. They were sometimes portrayed as heroic and noble, othertimes as savage and brutal, and othertimes, still, as symbolic of a vanishing, naive way of life.

In *Pocahontas* and *The Wept of Wish-ton-Wish,* Mozier subtly depicts the interaction between the Indian and the civilized western world. Pocahontas (c. 1595-1617), an historical figure, was an Indian maiden who saved Captain John Smith by intervening when he was captured by her father, the fierce and warlike Powhatan. She was later brought to the English colony of Jamestown, married an English gentleman, John Rolfe, and converted to Christianity (hence, the symbolism of the cross she is contemplating).

The companion sculpture, *The Wept of Wish-ton-Wish,* is based upon the 1829 romantic novel of the same name by James Fenimore Cooper. In contrast to Pocahontas' life, this story is of a white girl who is captured by Indians and chooses ultimately to remain with her brave and her adopted tribe rather than return to Christian civilization.

With the date of 1859, these sculptures appear to be the earliest versions known of the subjects. They are quite possibly the pair with identical marble pedestals shown in a photograph of the monumental entrance hall of the Norwalk, Connecticut, home of LeGrand Lockwood, and listed in the catalogue of the sale of the contents of the Lockwood mansion at Leavitt Art Rooms, 817 Broadway, New York, and Clinton Hall Book Sale Rooms, on April 18th and 19th, 1872.

Two other versions of *Pocahontas* are in private collections; one is dated 1868 and the other, 1877. Another version of *The Wept of Wish-ton-Wish,* dated 1869, is in the collection of the Arnot Art Museum, Elmira, New York.

Both sculptures retain their original marble pedestals.

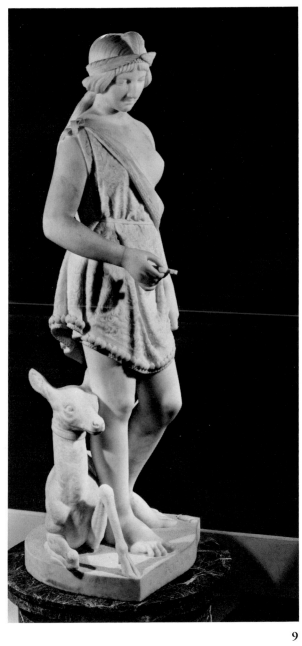

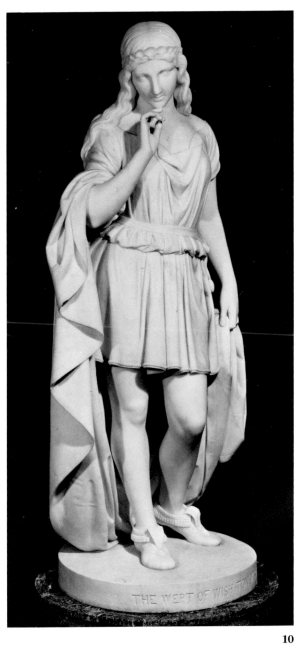

9

10

ALBERT BIERSTADT (1830-1902)

11. Study of Buffalo

Oil on canvas, 11⅜ × 15 in.

Dated (at lower right): Nov 1863

Bierstadt traveled through the American West for the second time with his friend the journalist Fitz Hugh Ludlow from April through November 1863. The artist made many "on the spot" oil sketches which he later incorporated into large studio paintings. These spontaneous and charming studies of buffalo reappear in varied form in such later paintings as *The Buffalo Trail* (1867-68, Museum of Fine Arts, Boston, Massachusetts) and, in particular, *Snow Scene with Buffaloes* (1867-68, formerly in the collection of Museum of Fine Arts, Boston). Related buffalo studies are in the collections of The Newark Museum, New Jersey, and the Thomas Gilcrease Institute of American History and Art, Tulsa, Oklahoma.

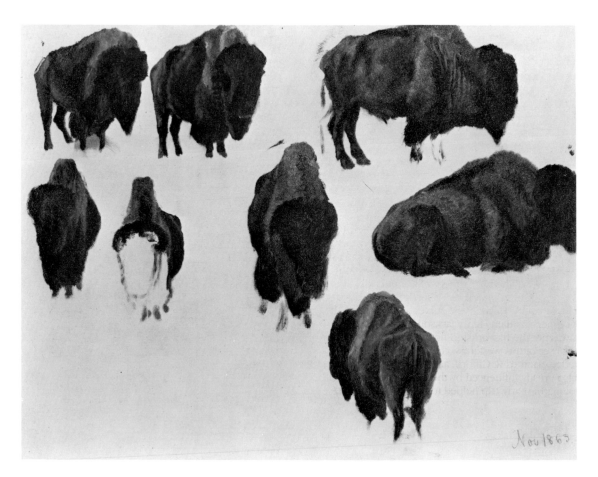

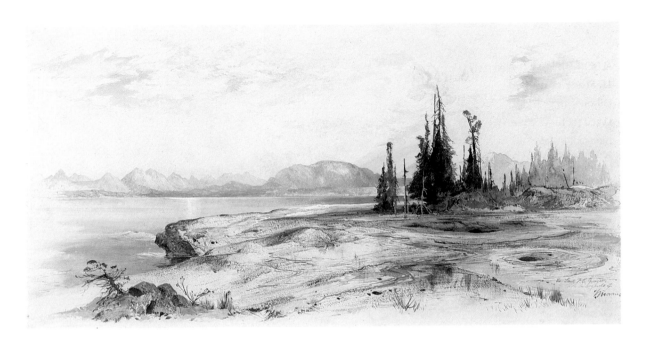

THOMAS MORAN (1837-1926)

12. Yellowstone Lake

Watercolor on paper, 9⅛ × 18⅝ in.

Signed and inscribed (at lower left): To Lieut. F. C. Grugan,/with the regards of/T.Moran.

Executed in 1871

EX COLL: the artist; to Lieut. F. C. Grugan, Philadelphia, Pennsylvania; to his daughter, Mrs. George B. Agnew, New York; by descent in her family, until 1981

By the 1870's, the United States government had begun to send survey expeditions, which included artists and photographers, to document and visually record the unspoiled grandeur of the American West. Between 1871 and 1892, Thomas Moran made eight trips to the trans-Mississippi West. In 1871, he made his first excursion to the Yellowstone region with a government expedition under the aegis of the Department of the Interior's United States Geological Survey of Territories. Headed by Dr. Ferdinand V. Heyden, the survey also included the photographers William Henry Jackson and J. Crissman. Moran was not the first artist to find inspiration in the vast expanses of this western sector; Worthington Whittredge, Sanford R. Gifford, and Albert Bierstadt were also greatly influenced by their trips to this region. For Moran, this early trip helped to catapult his career.

Yellowstone Lake relates to *The Yellowstone Lake with Hot Springs* (Thomas Gilcrease Institute of American History and Art, Tulsa, Oklahoma) and *Springs on the Border of Yellowstone Lake* (Yellowstone National Park, Wyoming), both painted about the same time. Moran's watercolors of the Yellowstone region, along with Jackson's photographs, influenced Congress to name Yellowstone, in 1872, the first national park.

WILLIAM JACOB HAYS, Sr. (1830-1875)

13. The Gathering of the Herds

Oil on canvas, 42 × 75 in.

Signed and dated (at lower left): W. J. Hays/1866

RECORDED: Maria Naylor, ed., *The National Academy of Design Exhibition Record 1861-1900,* I (1973), p. 417

EXHIBITED: National Academy of Design, New York, 1866, no. 391

During the summer of 1860, William Jacob Hays, Sr., made his only trip West, traveling up the Missouri River. From this experience, he painted over the succeeding six or ten years a number of important and large-scale landscapes showing vast herds of buffalo. Indeed, it was because of this fine and monumental series of paintings that the artist gained wide recognition both at home and abroad, including the praise of the contemporary critic Henry T. Tuckerman. Obviously impressed by the subject, Tuckerman wrote about a closely related painting, *The Herd on the Move,* in his *Book of the Artists* (1867), pp. 495-96:

> By the casual observer, this picture would, with hardly a second thought, be deemed an exaggeration; but those who have visited our prairies of the far West can vouch for its truthfulness.... As far as

the eye can reach, wild herds are discernible; and yet, farther behind these bluffs, over which they pour, the throng begins, covering sometimes a distance of a hundred miles. The bison collect in these immense herds during the autumn and winter, migrating south in winter and north in summer, and so vast is their number that travellers on the plains are sometimes a week in passing through a herd.

Paintings in Hays' buffalo series include *The Herd on the Move* (or *A Herd of Buffaloes on the Bed of the Missouri*), 1860-61 (Thomas Gilcrease Institute of American History and Art, Tulsa, Oklahoma); *Herd of Buffalo,* 1862 (Denver Art Museum, Colorado); and *Group of Buffalo,* 1860, *Wounded Bison,* 1862, and *The Stampede,* 1865 (all formerly in the collection of The American Museum of Natural History, New York). Although contemporary reviews of the 1866 National Academy of Design show do not specifically describe *The Gathering of the Herds,* the size, importance, and date of the present work indicate that it is the one included in that exhibition.

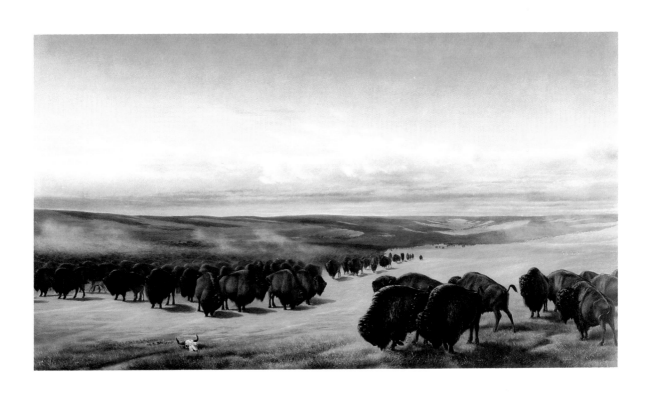

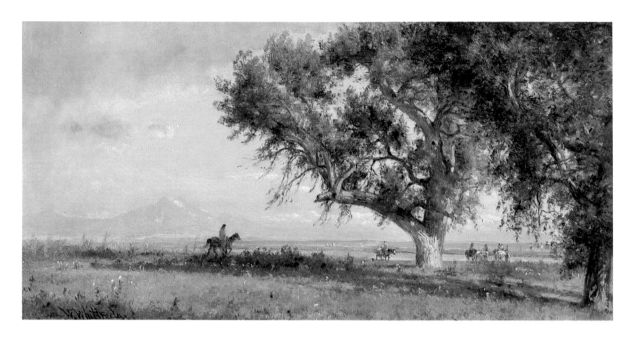

WORTHINGTON WHITTREDGE (1820-1910)

14. View on the Platte River

Oil on canvas, 8⅝ × 17½ in.

Signed (at lower left): W. Whittredge

Painted about 1871

EXHIBITED: Hirschl & Adler Galleries, New York, 1982-83, *Lines of Different Character—American Art from 1727 to 1947,* p. 40 no. 26 illus.

Whittredge made three trips West—in 1866, 1870, and 1871—and each time he visited the area of the Platte River in Colorado, where the Oto Indians had settled. The artist, who, "had never seen the plains or anything like them," recalled: "They impressed me deeply. I cared more for them than for the mountains, and very few of my western pictures have been produced from sketches made in the mountains, but rather from those made on the plains with the mountains in the distance. Whoever crossed the plains at that period . . . could hardly fail to be impressed with its vastness and silence and the appearance everywhere of an innocent, primitive existence" [John I. H. Baur, ed., "The Autobiography of Worthington Whittredge," in *Brooklyn Museum Journal,* I (1942), p. 45].

Anthony Frederick Janson, who has done extensive work on Worthington Whittredge, wrote in a letter dated October 12, 1982 [Hirschl & Adler Galleries archives]: "The only signed and dated work from [Whittredge's 1871 trip] is a drawing of trees in the Karolik Collection, Boston Museum of Fine Arts. [*View Along the Platte River*] is sufficiently different from the 1870 Western oil sketches and sufficiently close to the Karolik drawing to warrant placing it in 1871, which would make it a very rare item indeed."

In "The Paintings of Worthington Whittredge" [unpub. Ph.D. dissertation, Harvard University, Cambridge, Massachusetts (1975), pp. 86-87], Janson observed: "The Western sketches and their studio counterparts constitute the largest coherent group of paintings in Whittredge's oeuvre and, despite their modest dimensions, attest to the importance the artist attached to the expedition. In many respects, they represent the culmination of his initial development as a Hudson River artist"

ALBERT BIERSTADT (1830-1902)

15. View in Yosemite Valley

Oil on paper, 20⅛ × 25 in.

Painted about 1872

EXHIBITED: Alexander Gallery, New York, 1983, *Albert Bierstadt,* [n.p.] no. 10 illus. in color

Bierstadt first visited the Yosemite Valley, California, during the summer of 1863 and returned there for the late winter, spring, and early summer of 1872. The artist was awed by the setting; at times it was monumental and overwhelming in scale, at others, intimate and of human proportions. Yosemite Valley was to be a recurrent subject in Bierstadt's paintings from 1863 on; its variety is reflected in the many diverse paintings of varying scale that resulted from his trips there.

View in Yosemite Valley was probably painted during the summer of 1872. Although it is larger and more finished than most of the oil sketches made on site, its freshness and vitality suggest it may have been executed there. The dark tonalities and careful attention to detail reflect the artist's early Düsseldorf training.

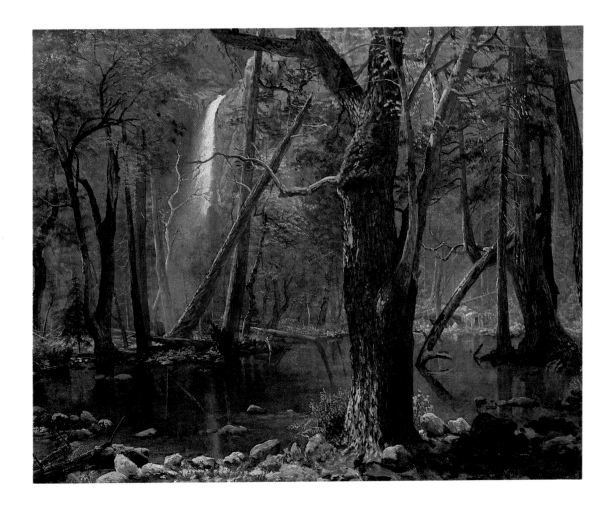

THOMAS MORAN (1837-1926)

16. Hot Springs of Gardiners River, Yellowstone National Park, Wyoming Territory

Watercolor on tinted tan paper, 20¼ × 28⅝ in.

Signed and dated (at lower right): TM[monogram]ORAN. /1872.

RECORDED: Thomas Moran, "Notebook" (unpub. ms., Thomas Gilcrease Institute of American History and Art, Tulsa, Oklahoma, 1874, 1878, 1879, 1882) // W. H. Jackson, "Famous American Mountain Paintings, Part I: With Moran in the Yellowstone, A Story of Exploration, Photography and Art," in *Appalachia,* XXI (Dec. 1936), pp. 154-55 // Mildred Byars Matthews, "The Painters of the Hudson River School in the Philadelphia Centennial of 1876," in *Art in America,* XXXIV (July 1946), p. 158 // Fritiof Fryxell, ed., *Thomas Moran, Explorer in Search of Beauty* (1958), pp. 9, 55-57 // Thurman Wilkins, *Thomas Moran Artist of the Mountains* (1966), pp. 62-63, 204 // Barbara Novak, "On Diverse Themes from Nature," in *The Natural Paradise, Painting in America 1800-1950* (1976), p. 80 illus. // Theodore E. Stebbins, Jr., *American Master Drawings and Watercolors* (1976), pp. 164 fig. 130 in color, 165-66, 170, 426 // Susan Hobbs, "The Selection Process at the Centennial," in *1876: American Art of the Centennial* (1976), p. 8 // Donelson F. Hoopes, *American Watercolor Painting* (1977), pp. 18, 116 pl. 20 // Carol Clark, *Thomas Moran—Watercolors of the American West* (1980), pp. 39-41, 42 footnote 19, 79 illus., 129-30 no. 46 // James Maroney, Inc., New York, *A small group of Especially Fine American Works on Paper* (1984), [n.p.] no. 2 illus. in color

EXHIBITED: Annex Gallery, No. 16, Department IV-Art, Philadelphia, Pennsylvania, 1876, *International Exhibition,* p. 28 no. 376 // Hirschl & Adler Galleries, New York, 1972-73, *Faces and Places: Changing Images of 19th Century America,* [n.p.] no. 68 illus. // The Museum of Modern Art, New York, 1976, *The Natural Paradise, Painting in America, 1800-1950,* p. 80 [n.n.] illus. // The Minneapolis Institute of Arts, Minnesota, Whitney Museum of American Art, New York, and The Fine Arts Museums of San Francisco, California, 1976-77, *American Master Drawings and Watercolors,* no. 130 // Amon Carter Museum of Western Art, Fort Worth, Texas, The Cleveland Museum of Art, Ohio, and Yale University Art Gallery, New Haven, Connecticut, 1980-81, *"The Most Remarkable Scenery," Thomas Moran's Watercolors of the American West,* pp. 40, 79 no. 46 illus. // Hirschl & Adler Galleries, New York, 1982-83, *Lines of Different Character—American Art from 1727 to 1947,* pp. 44-45 no. 30 illus. in color, frontispiece p. 2 illus. in color // New Orleans Museum of Art, Louisiana, 1984, *The Waters of America,* p. 87 illus.

EX COLL: the artist, 1872-84; by gift from the artist and Arthur G. Renshaw, London, England, to Geological Society of London, 1884-1972; to [sale, Sotheby's Belgravia, London, England, May 31, 1972, p. 16 no. 40 illus.]; to [Hirschl & Adler Galleries, New York, 1972]; to Barbara Millhouse, Winston-Salem, North Carolina, 1972-82

Hot Springs of Gardiners River became a favored subject in Moran's watercolors of the 1870's. He included at least one view in each of the sets he undertook as commissions, notably for William Blackmore, Jay Cooke, and Louis Prang, and chose the Springs for this, his largest and most impressive watercolor. In the artist's "Notebook" [*loc. cit.*], he recorded: "Lg wc drwg of the Hot Springs of Gardiner's River 22 × 29 made in 4 days Nov 8th 1872. Exhibited at Shaw's & in Washington & it is there yet Feb 28. 1874/have it still 1878." In another document at the Gilcrease Institute, Moran noted: "Hot Springs Yellowstone Water Color 20 × 30 Now at Phila. Ex Nov 1879/Still in Eng 1882."

Of this work Theodore E. Stebbins, Jr., wrote [*op. cit.,* p. 166]: "Most impressive [of the Yellowstone watercolors made during the early 1870's] is the large watercolor *Hot Springs of Gardner's* [sic] *River . . .;* here Moran combines the Turneresque with the Pre-Raphaelite, and adds as well his own originality of technique. The vision is a perfect one: using a rather dry touch and a limited range of hue, concentrating on whites, reds, and blues, Moran creates an other-worldly scene with no sign of the artist's intrusion. Moonlike rocks and hot pools of water are brushed in with infinite care, the tinted tan paper now being used to great advantage, with astonishing, fluid lines of red ink leading one into the composition and off into the distance."

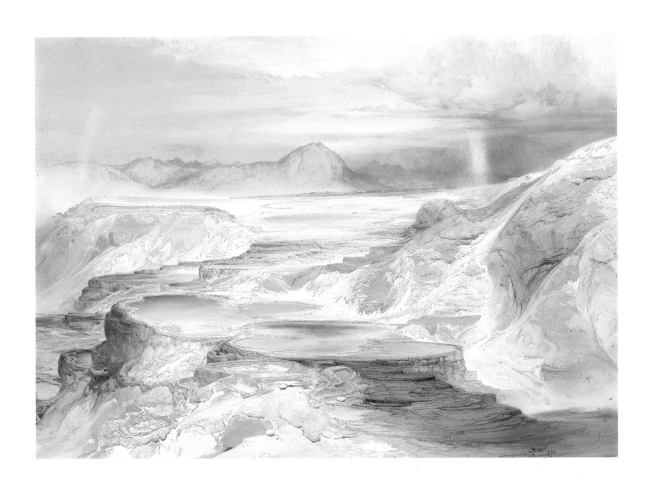

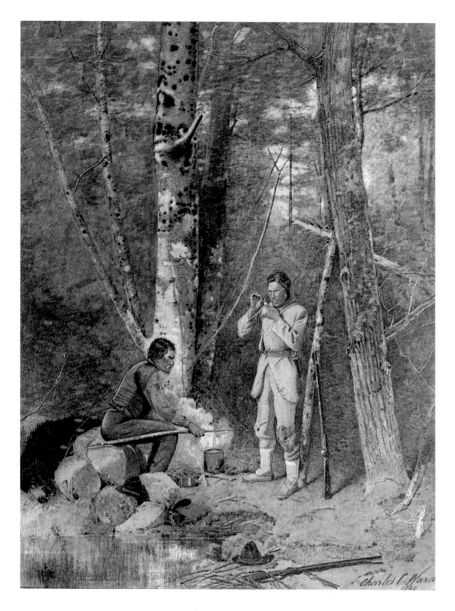

CHARLES CALEB WARD (c. 1831-1896)

17. After the Bear Hunt

Watercolor on paper, 9 × 7 in.

Signed and dated (at lower right): Charles C. Ward/1880

A Canadian born in New Brunswick, Charles C. Ward is known to have been living in New York in 1850-51 and again from 1868 to 1872. By 1881, the year after the present work was executed, records of the National Academy of Design, New York, indicate that the artist again resided in his birthplace of St. John, New Brunswick.

This watercolor of 1880 is nearly identical in composition to an oil painted the following year, measuring 14 × 12 in., formerly in the collection of Hirschl & Adler Galleries, New York, and now, presumably, still in a private collection. Ward exhibited a work in 1883 at the National Academy of Design titled *The Bear Slayers* (no.

693), which was priced at $300.00. Because of the relative high price, it is unlikely that either the present watercolor or the 1881 oil was shown that year at the National Academy. However, the title of the presumed-large picture suggests that it may bear strong resemblance to the two earlier works, particularly since their close relationship demonstrates that the artist repeated compositions.

Ward was known for his portraits, landscapes, and genre compositions. Set in a frontier context, *After the Bear Hunt* shows an intimate, commonplace scene where each trapper is intently engaged in his respective activity. The fierce battle which must have preceded is only suggested by the slain bear lying off to the side, almost out of view.

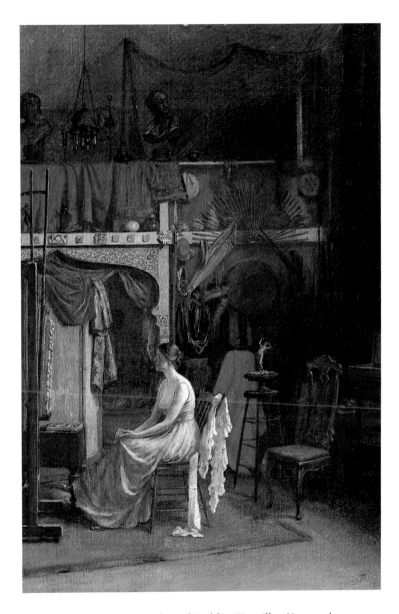

JOSEPH HENRY SHARP (1859-1953)

18. In the Studio

Oil on canvas, 32¾ × 22¼ in.

Signed and dated (at lower right): J. H. Sharp/97

EXHIBITED: Hirschl & Adler Galleries, New York, 1982-83, *Lines of Different Character—American Art from 1727 to 1947,* p. 68 no. 51 illus. in color

EX COLL: [Hirschl & Adler Galleries, New York, 1978-79]; to private collection, 1979-84

Along with Eanger Irving Couse, Ernest Blumenschein, and Bert Phillips, Joseph Sharp is closely associated with the art colony that was established in Taos, New Mexico, in 1898. Sharp first traveled to the American Southwest on a sketching trip in 1883, and was fascinated by the various tribes of Pueblos, Umatillas, Utes, and Shoshones. Revisiting New Mexico in 1893, he went to Taos, where he soon established a routine of sketching the American natives there during the summer, while finishing the oils in his Cincinnati studio during the winter. Throughout this time the artist accumulated a large collection of Indian artifacts and costumes which would occasionally be used as props for his studio pieces. In 1895 Sharp returned to Europe, where he had received his early training, for an additional two years of study and travel. *In the Studio* was probably painted upon the artist's return to Cincinnati in the autumn of 1897. His Indian relics and European souvenirs decorate the studio interior, and it is possible that the seated model is Sharp's wife, the former Addie Byram.

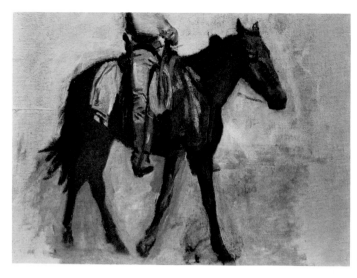

19

20

THOMAS EAKINS (1844-1916)

19. Sketch for "Cowboys in the Badlands"

Oil on canvas, 10¼ × 14¼ in.

20. Portrait Sketch of Edward Boulton

Oil on canvas, 10¼ × 14¼ in.

Both painted 1887-88

RECORDED: Lloyd Goodrich, *Thomas Eakins: His Life and Work* (1933), p. 180 no. 230, as *Cowboy (Sketches)* // William Innes Homer, "Thomas Eakins and The Avondale Experience," in *Arts* (Feb. 1980), p. 151 illus. (records *Portrait Sketch of Edward Boulton*)

EXHIBITED: Hirschl & Adler Galleries, New York, 1978, *American Genre Painting in the Victorian Era—Winslow Homer, Eastman Johnson, and their Contemporaries,* p. 18 nos. 17a and 17b illus. // Brandywine River Museum, Chadds Ford, Pennsylvania, 1980, *Eakins at Avondale* and *Thomas Eakins: A Personal Collection,* p. 37 nos. 12 and 13

EX COLL: Edward Boulton; to his wife, Mrs. Edward Boulton, New Preston, Connecticut

During the summer of 1887, Eakins spent two and one-half months in the Badlands of the Dakota Territory, where he stayed at the B-T Ranch, near Dickinson. Upon his arrival, he bought two horses—Baldy, a brown Indian pony, and Billy, a white horse—which accompanied him when he returned to his family's Avondale, Pennsylvania, farm in October of that year.

Both of these oil studies were probably painted after Eakins' return to Avondale. The *Sketch for "Cowboys in the Badlands"* almost certainly depicts Baldy, while the subject of the companion sketch is Edward Boulton, a painter and student of Eakins' at the Art Students League in Philadelphia. Both works were later incorporated into Eakins' major western painting titled *Cowboys in the Badlands* of 1888 (private collection).

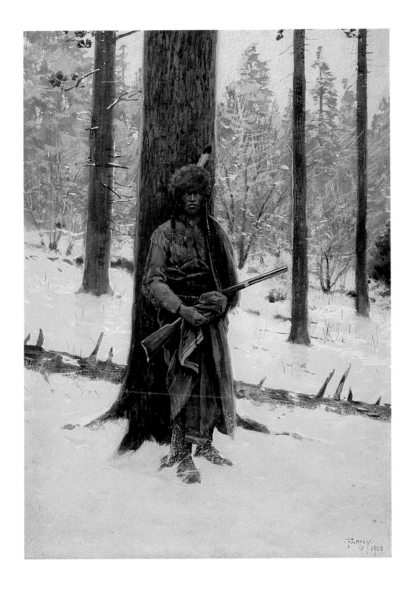

HENRY F. FARNY (1847-1916)

21. Indian Under a Tree

Watercolor and gouache on paper, 11⅜ × 8½ in.

Signed, dated, and inscribed (at lower right): ·FARNY·/⊙ [insignia] 1900

EX COLL. private collection, St. Louis, Missouri, until 1982

By 1900, Henry François Farny had successfully established himself as a painter of Indians and the American West. He started his career as an illustrator, and became an accomplished one at that, working for such well-known publications as *Harper's* and *Century Magazine*. In 1893, he gave up illustration entirely to devote himself to painting the American Indian. The artist made several trips West between 1881 and 1894, where he drew numerous sketches, took photographs, and gathered artifacts, which later served as models for the paintings done in his Cincinnati, Ohio, studio. His pictures were in great demand locally and patrons often had to wait a considerable period of time for works they had commissioned from him.

Indian Under a Tree relates in composition to several other gouaches, largely still in private collections in the Cincinnati area, which are variously titled *In the Pine Woods, Deer Hunting, The Broken Twig, A Moment of Suspense,* and *The Moose Horn,* dating from 1900 to 1906. With the date of 1900, the present picture appears to be one of the earliest paintings of this type now known. As in all of Farny's pictures, the Indian is shown with dignity and understanding; nostalgia for a time gone by or popular conceits of the Indian as savage do not enter into the artist's work.

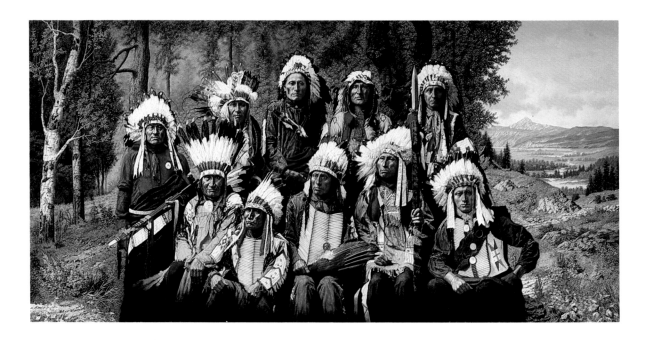

ELBRIDGE AYER BURBANK (1858-1949)

22. Prince Jack Red Cloud and Chiefs, Ogallala Sioux

Oil on canvas, 60 × 120 in.

Painted about 1895-1900

EX COLL: the artist, until 1949; by bequest to the Elks Club, San Francisco, California, 1949-78; to Gian Campanile, San Francisco, California, 1978-84

E. A. Burbank was born in Harvard, Illinois, and studied at the Academy of Design, Chicago. After painting scenes along the Northern Pacific Railway on an assignment from *Northwest Magazine,* he moved to Munich to study with Paul Nauen and Fredrick Fehr. Among his fellow students there were Joseph Henry Sharp and William R. Leigh. Burbank returned to Chicago in 1892 and began studying and painting black children in the area. In 1895, however, his uncle, Edward E. Ayer, founder of the Ayer Indian Collection, Chicago, commissioned him to create a series of Indian portraits, which directed the course of his work for the rest of his life.

Prince Jack Red Cloud and Chiefs, like all of Burbank's Indian subjects, is executed with great attention to accuracy and detail. It is an invaluable document both in the carefully observed facial features of each of the chiefs and in their meticulously rendered ceremonial costumes. The same careful scrutiny is applied to the shimmering landscape in the background. Of the works depicting 125 types of North American Indians that Burbank was to paint before his death in 1949, *Prince Jack Red Cloud and Chiefs* stands as the most monumental, both in size and in scope.

Burbank observed in his autobiography, *Burbank Among the Indians* (1946), p. 127, that, "one of the greatest of the Sioux Chiefs was Red Cloud." The artist continued: "He was a 'good Indian,' meaning a chief who had held his tribe in line and had abided by the treaties made with the white men even though the whites themselves consistently disregarded the treaties. Red Cloud had made numerous trips to Washington to see the Great White Father on behalf of the Sioux."

The Indian Chiefs depicted are, front row, left to right, Rocky Bear, Broken Arm, Jack Red Cloud, Black Heart, and High Hawk, and, back row, left to right, Painted Horse, Standing Bear, Bird Head, Black Horn, and George Little Wound.

FREDERIC REMINGTON (1861-1909)

23. Halt—Dismount!

Oil on canvas, 30¼ × 51⅜ in.

Signed and dated (at lower right): Frederic
Remington/1901

RECORDED: Harold McCracken, *A Catalogue of the
Frederic Remington Memorial Collection* (1954), pp. 33,
35 illus. // Harold McCracken, *The Frederic Remington
Book* (1966), p. 110 fig. 143 // Timken Art Gallery, San
Diego, California, *European and American Works of Art
in the Putman Foundation Collection* (1983), pp. 91, 92,
106 no. 40, 107 illus., 126 no. 40

EXHIBITED: Palm Springs Desert Museum, California,
1982, *The West as Art,* no. 121, pl. 100

EX COLL: Commissioned by Benjamin Walworth Arnold,
Albany, New York; descended to his grandson, Arnold
Cogswell, Albany; to Putnam Foundation Collection, San
Diego, California, 1977-84

Halt—Dismount! was commissioned by Benjamin W.
Arnold of Albany, New York, in 1901. On a preliminary
pen sketch offered to Arnold for his consideration,
Remington wrote his own description of the scene:

> Being a cavalry column—suddenly fired on from
> opposite bluffs—the officer raising hand indicating
> "Halt—+ bugler blowing—white and indian scouts
> in center and all the troop horses twisting back on
> their bits. It gives good chance for action of rather
> unconventional form. Canvas about 50 inches long.

Remington based the subject of his final painting on an
incident taken from the Indian Wars. Painted just ten
years after The Battle of Wounded Knee when the artist
was at the height of his creative powers, *Halt—
Dismount!* is an outstanding example of Remington's
ability to capture on canvas a moment of intense action
and excitement, and is characteristic of his best oils and
bronzes. This painting is accompanied by copies of two
letters to Benjamin Arnold and a copy of Remington's
preliminary sketch.

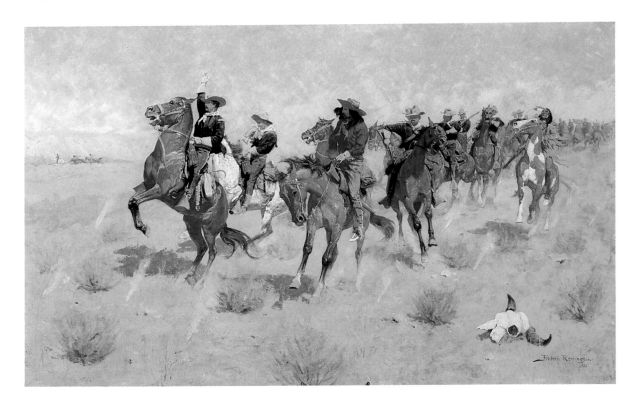

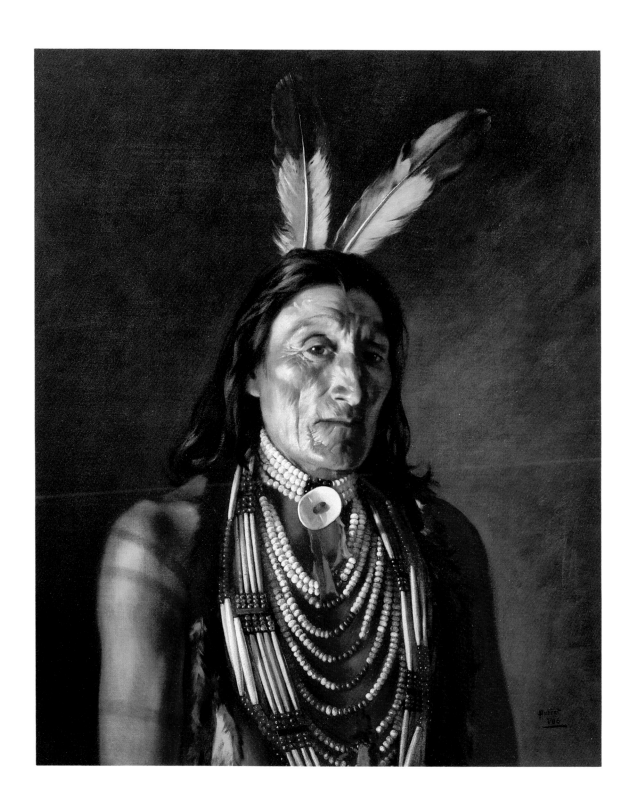

HUBERT VOS (1855-1935)

24. Sioux Indian Chief in Ceremonial Beads

Oil on canvas, 36 × 30 in.

Signed (at lower right): Hubert/VOS

Painted about 1896

RECORDED: John Bandiera, "An Examination of the Art and Career of Hubert Vos," June 1976 (unpub. ms., Hirschl & Adler Galleries archives), p. 11 fig. 10

EXHIBITED: Union League Club of New York, New York, 1900, *Types of Various Races: Portraits by Hubert Vos,* [n.p.] no. 33, as *Sioux Indian in War Dress* // The Corcoran Gallery of Art, Washington, D.C., 1900, *Portraits by Hubert Vos,* [n.p.][n.n.] // Stamford Museum, Connecticut, 1979, *Hubert Vos,* p. 2 no. 7 illus.

EX COLL. estate of the artist, until 1984

Born in Maastricht, Holland, Hubert Vos began his study of art at the Académie Royale de Bruxelles, as a pupil of Jan Frans Portaels. During the 1870's, he continued his training in the Parisian atelier of Fernand Cormon, and, with a grant from the Dutch government, completed his studies in Rome, Italy. By the 1880's, he had won numerous awards and distinctions. Influenced early on by Dutch realism, he naturally gravitated towards verisimilitude, but, more importantly, sought throughout his career subjects of diverse ethnic and social backgrounds.

Vos was recognized during his lifetime as a successful portrait painter, his patrons largely being influential and renowned—diplomats, industrialists, and royalty. Another equally important aspect of his work, however, were his ethnological portraits. These were initially inspired by his sojourn to America in 1892 as Holland's Royal Commissioner of Fine Arts for the World's Columbian Exposition in Chicago. About this aspect of his work, Vos commented [Bandiera, *op. cit.,* p. 10]:

> ... I began to study the works I could get hold of on Ethnology and was shocked to see what poor specimens the principle authors had to illustrate their very superior works. I thought it might be possible to establish a type of beauty of the different original aboriginal races before they became too much mixed or extinct and soon got to work.

Intrigued by the diversity of American culture following his stay in Chicago, Vos organized an extensive four-year world tour, which included the western United States, South America, Polynesia, Japan, Malaysia, China, and Tibet. *Sioux Indian Chief in Ceremonial Beads* is one in a series of portraits of North American Indians executed during this period. Here, a Sioux chief attired in typical battle dress assumes his role as warrior and leader of his tribe.

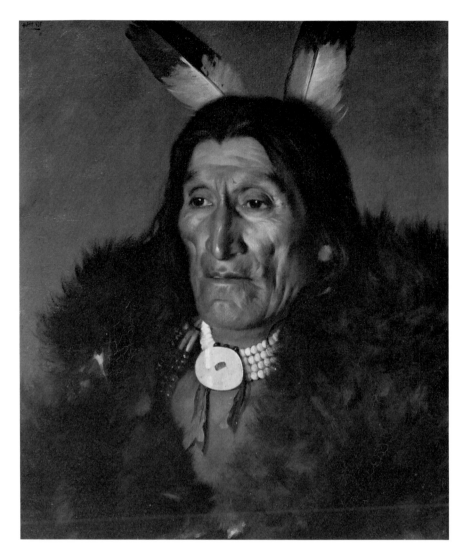

HUBERT VOS (1855-1935)

25. Sioux Chief in Buffalo Robes

Oil on canvas, 24 × 20 in.

Signed and dated (at upper left): Hubert/VOS/97

RECORDED: John Bandiera, "An Examination of the Art and Career of Hubert Vos," June 1976 (unpub. ms., Hirschl & Adler Galleries archives), facing p. 11 fig. 9

EXHIBITED: Union League Club of New York, New York, 1900, *Types of Various Races: Portraits by Hubert Vos,* [n.p.] no. 28 // The Corcoran Gallery of Art, Washington, D.C., 1900, *Portraits by Hubert Vos,* [n.p.][n.n] // Stamford Museum, Connecticut, 1979, *Hubert Vos,* p. 2 no. 8 illus.

EX COLL. estate of the artist, until 1984

Like George Catlin, Alfred Jacob Miller, Karl Bodmer, and Rudolph Frederich Kurz before him, Vos set out in 1893 to depict a rapidly vanishing race. By this time the American western frontier had ostensibly reached its apogee, and President Andrew Jackson had long since initiated governmental legislation (Indian Removal Act of 1830) that signalled the inevitable demise of native American Indians. By 1900, their fate was sealed. If Catlin, concerned with recording specific individuals within particular tribes, painted his subjects with scientific objectivity, Vos, though equally concerned with ethnological and physiognomic accuracy, brought to his subjects strong romanticism. In this respect, *Sioux Chief in Buffalo Robes* reflects an ideal rather than an individual. By focusing on the universal aspects of his subject, Vos created a generic archetype, in his words, "a type of beauty," that came to symbolize the degradation and psychological hardships endured by an entire tribe. In all likelihood, the Sioux represented here is the same sitter as in the previous painting. By depicting the same chief in varied garb, Vos suggests the many roles assumed by a tribal leader; in contrast to the belligerent overtones of its counterpart, *Sioux Chief in Buffalo Robes* represents the chief as judicial advisor, wiseman, and mediator within his tribe.

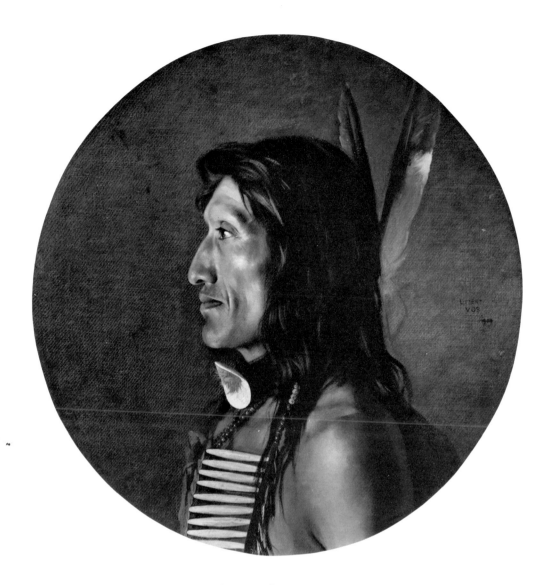

HUBERT VOS (1855-1935)

26. Chippewa Indian Chief

Oil on canvas, tondo 26 in. (diameter)

Signed and dated (at right center): HUBERT VOS/1900

EXHIBITED: Union League Club of New York, New York, 1900, *Types of Various Races: Portraits by Hubert Vos,* [n.p.] no. 31 // The Corcoran Gallery of Art, Washington, D.C., 1900, *Portraits by Hubert Vos,* [n.p.][n.n.] // Stamford Museum, Connecticut, 1979, *Hubert Vos,* pp. 1 illus. in color, 3 no. 9 illus. // Art Association of Newport, Rhode Island, 1981, *Hubert Vos Retrospective,* [n.p.][n.n]

EX COLL. estate of the artist, until 1984

Painted somewhat later than its companion pieces, *Chippewa Indian Chief* is also characterized by strong psychological overtones. In general, Vos consistently brought to his portraiture an academician's control and impeccable draughtsmanship; strong design and subtle modeling in color make each of these portraits significant visual images, as well as poignant anthropological records.

FREDERICK MacMONNIES (1863-1937)

27. Study for "The Pioneer Mother"

Painted plaster, 11 in. high × 15 in. wide × 6 in. deep

Executed about 1905-10

RECORDED: *cf.* "The MacMonnies Pioneer Monument for Denver: An Embodiment of the Western Spirit," in *The Century Magazine,* LXXX (Oct. 1910), pp. 876-80, "The Pioneer Mother" p. 879 illus. // David Weir, "Old Bronze/New World," in *Art/World,* XI (April/May 1982), records this plaster p. 9

EXHIBITED: Hirschl & Adler Galleries, New York, 1982, *Carved and Modeled: American Sculpture 1810-1940,* p. 68 no. 37 illus., as *Study for "The Pioneer Woman".*

EX COLL. descended in the family of the sculptor, until 1980

Although somewhat different from the finished group, this plaster clearly is a preliminary study for "The Pioneer Mother" on MacMonnies' *Pioneer Monument* of 1910 in Denver, Colorado. The monument consists of three groupings, "The Hunter," "The Prospector," and "The Pioneer Mother," which surround a central equestrian figure of "Kit Carson." Of "The Pioneer Mother," an unidentified author in *The Century Magazine* wrote [*loc cit.*]: "In the group of mother and child, [MacMonnies] has endeavored to reflect the high qualities of courage and resourcefulness of the pioneer woman, always ready to meet danger in defense of her child and home."

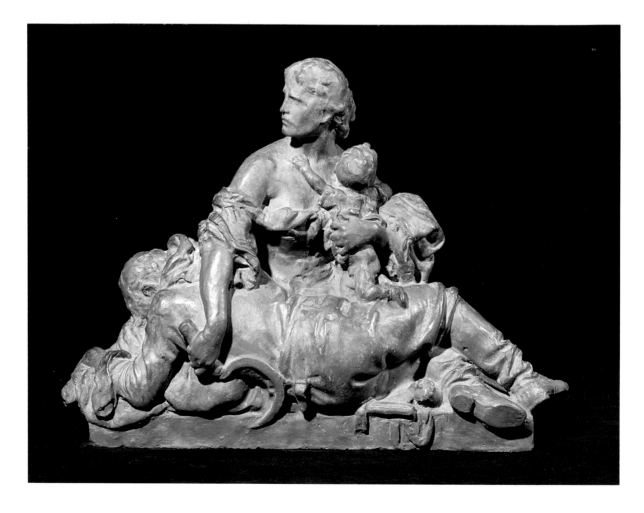

ASTLEY D. M. COOPER (1856-1924)

28. Trophies of the Buffalo Hunt

Oil on canvas, 44½ × 30 in.

Signed (at lower left): A. D. M. Cooper

Painted about 1910

Considering Astley D. M. Cooper's family background, it is not surprising that he became intrigued with the western frontier. His maternal grandfather was Major Benjamin O'Fallon, Indian Agent for the Missouri River Tribes and a personal friend of George Catlin; his great-uncles were the famous frontier soldier George Rogers Clark and the explorer William Clark. As a boy growing up in St. Louis, Missouri, Cooper immersed himself in the history of the frontier. His research culminated in Indian portraits, painted before he reached the age of twenty-five, which brought him recognition. By the time he moved to San José, California, in 1883—where he remained until his death—he had established a notable reputation for his Indian subjects.

Cooper's interpretations of the frontier are often laced with irony and satire. *Trophies of the Buffalo Hunt* is an assemblage of Indian paraphernalia, a buffalo's head and an Indian's portrait. Reduced to formal, inanimate elements in a *trompe l'oeil* still life, Indian and buffalo alike become nostalgic symbols, objects in a painted pastiche that signify the historic passage of American Indian culture.

WILLIAM ROBINSON LEIGH (1866-1955)

29. Thunder Mountain

Oil on canvas, 40½ × 72¼ in.

Signed and inscribed (at lower right): W R Leigh/©

Painted about 1910-15

EX COLL: the artist, until 1954; to the Mercersburg Academy, Pennsylvania (purchased through an unidentified exhibition at the Washington County Museum of Fine Arts, Hagerstown, Maryland), 1954-83

As his fellow artist Thomas Moran had done before him, William R. Leigh first traveled to the Southwest in 1906 on a Santa Fe Railroad ticket given in exchange for a painting of the Laguna and Zuni region of New Mexico. Leigh was immediately impressed by the beauty of the country and the lives of the local Indian population and returned to the Southwest frequently throughout the rest of his life.

During the 1906 trip, Leigh first saw Taaiyaolone, or Mountain of Thunder, seven miles from the Zuni pueblo. He painted and sketched the scene several times, resulting in this large and impressive studio painting, as well as such other related works as *Sacred Mountain of the Zuni* of 1911 [*cf.* June DuBois, *W. R. Leigh: The Definitive Illustrated Biography* (1977), p. 54 illus.]. Describing the view at sunset, the artist observed: "The sacred mountain, one thousand feet high [was] now bathed in the magical light of the red, low sun while the town and the plains were already in shadow. It was a magical spectacle. Two great shafts of rock stood apart—twin gods according to Zuni mythology. ... I painted every day and all day" [*ibid.,* p. 56].

In a photograph of Leigh's studio at 200 West 57th Street, New York, which, according to Bruce Etchison, former Director of the Washington County Museum of Fine Arts, was taken around 1920, *Thunder Mountain* is shown on the easel [*cf.* David C. Hunt, "W. R. Leigh: Portfolio of an American Artist," in *American Scene Magazine,* VII (1966), illus. inside front and back covers, and DuBois, *op. cit.,* p. 192 illus.].

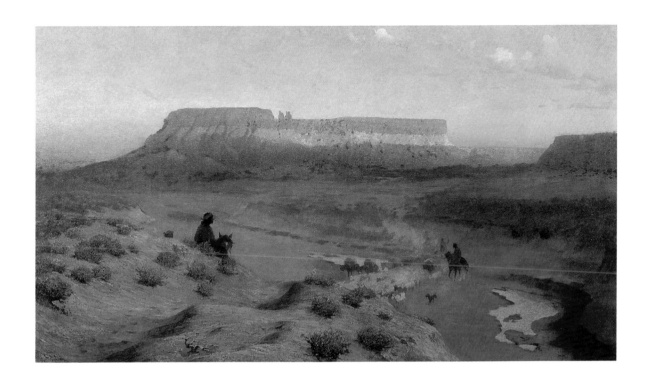

FRANK A. MECHAU (1904-1946)

30. Pony Express

Oil, tempera, and pencil on linen, 25 × 54½ in.

Signed (at lower right): f. mechau jr

Painted in 1935

RECORDED: Inslee A. Hopper, "America in Washington," in *The American Magazine of Art,* XXVIII (Nov. 1935), pp. 719 illus., 720 // Audrey McMahon, "The Trend of the Government in Art," in *Parnassus,* VIII (Jan. 1936), p. 6 illus. // "On Government Service," in *Survey Graphic,* XXV (Jan. 3, 1936), p. 32 illus. // "Colorado Springs Artist Painting Murals of Pioneer Days of Mail for Post Office Buildings," in *Colorado Springs Gazette and Telegraph* (Feb. 16, 1936), sec. 2, p. 2 col. 2 illus. // Martha Davidson, "New Directions in Native Painting," in *The Art News,* XXXV, no. 31 (May 1, 1937), p. 152 illus. // Kaj Klitgaard, *Through the American Landscape* (1941), p. xi, facing p. 244 illus.

EXHIBITED: Corcoran Gallery of Art, Washington, D.C., 1935, *Exhibition of Small-Scale Designs for the Treasury Relief Art Project, Entries for Washington, D.C. Federal Buildings* // Studio of Frank Mechau, Colorado Springs, Colorado, 1936 // Museo Nacional de Bellas Artes, Buenos Aires, Argentina, 1941, *Exposición de Pintura Norteamericana Contemporánea,* pp. 24 no. 92, 83 illus. // The Denver Art Museum, Colorado, 1946, *Frank Mechau, 1904-1946, Memorial Exhibition,* pp. 7 no. 21, 8 illus. // The Denver Art Museum, Colorado, 1972, *Frank Mechau Retrospective, 1904-1946,* pp. 6, 9 illus., 17 no. 18 // Aspen Center for the Visual Arts, Colorado, and the University of Colorado Art Gallery, Boulder, 1981-82, *Frank Mechau, Artist of Colorado,* pp. 32, 34-35 illus., 37, 44 illus., 73, 75 [n.n.]

EX COLL: the artist, 1935-36; to Mr. A. Conger Goodyear, 1936; by gift to public institution, 1936-83

31. Dangers of the Mail

Oil, tempera, and pencil on linen, 25 × 54½ in.

Signed (at lower left): f mechau jr

Painted in 1935

RECORDED: "On Government Service," in *Survey Graphic* (Jan. 3, 1936), p. 33 illus. // *Time Magazine* (March 2, 1936), illus. in color // Peggy and Harold Samuels, *The Illustrated Biographical Encyclopedia of Artists of the American West* (1976), p. 319

EXHIBITED: Corcoran Gallery of Art, Washington, D.C., 1935, *Exhibition of Small-Scale Designs for the Treasury Relief Art Project, Entries for Washington, D.C. Federal Buildings* // New York, 1935, *International Show of Mural Artists of the World* // Studio of Frank Mechau, Colorado Springs, Colorado, 1936 // Museum of Modern Art, New York, 1937, *Paintings for Paris, by Thirty-six Living American Artists Who Will be Among Those Represented in the Retrospective Exhibition ... Opening in Paris in May 1938,* [n.p.] no. 31 // Musée du Jeu de Paume, Paris, France, 1938, *Trois Siècles d'Art aux États-*

Unis, p. 43 no. 124, as *Les Dangers de la Poste* // The Denver Art Museum, Colorado, 1946, *Frank Mechau, 1904-1946, Memorial Exhibition of Paintings and Drawings,* p. 7 no. 20 // The Denver Art Museum, Colorado, 1972, *Frank Mechau Retrospective, 1904-1946,* pp. 6, 8-9 illus., 17 no. 17 // Aspen Center for the Visual Arts, Colorado, and the University of Colorado Art Gallery, Boulder, 1981-82, *Frank Mechau, Artist of Colorado,* pp. 32, 33 illus., 37-38, 39, 71, 73, 75

EX COLL: the artist, 1935-36; to Mr. A. Conger Goodyear, 1936; by gift to public institution, 1936-83

Frank Mechau lived a short but productive life. Though raised in Glenwood Springs, Colorado, he was cosmopolitan and well-traveled. His worldliness—a three year sojourn from 1929-1932 in Paris, with a trip to Italy—however, was tempered by his admiration for the American Southwest. At a time when American painting alternated between eclectic modernism and academic classicism, Mechau chose to depict the American scene without seeming too eclectic or academic. His style was personal and sincere; his philosophic outlook reflected a grass roots optimism embodied in the writings of the architect Frank Lloyd Wright and the poet Walt Whitman. During the 1930's, Mechau was given the opportunity to design murals under the Treasury Section of Painting and Sculpture. Edward Bruce, who directed the Treasury "Section" and the WPA-funded Treasury Relief Art Project, and who knew Mechau's work, invited him to submit designs for several post offices in his region (Washington, D.C.) and the Southwest. *Dangers of the Mail* and *Pony Express* were both executed in 1935 for the Post Office Department Building, in Washington, D.C. In a letter written to Henry Allen Moe, Secretary of the Guggenheim Foundation [Aspen Center for the Visual Arts, *op. cit.,* p. 32], just prior to his receiving the commission, Mechau described his program in detail:

> ... For about five months I have scarcely left the studio.... However, the two large and ten small compositions that emerged from the effort carry a reward of their own....
> One panel, "Dangers of the Mail," is composed of a whirling horde of Indians closed in upon an overturned stagecoach with a pile of dead and dying whites who have been partially disrobed for loot. The other one, "Pony Express," is a static contrast to the chaos of the massacre. A pony rider is tossing the mochila (the mail pouch that fitted over the saddle) on to a fresh mustang as the horse he rode into the division point from the last station (fifteen miles) is turned into a coral. The scene of horses, corrals, the station and several riders examining their carbines is starkly placed against a spatial Veronese green sky. One looks down across a waste land stretch of sand dunes towards a range of mountains stretching the length of the panel.

A full double-page color reproduction of *Dangers of the Mail* that appeared in *Time Magazine,* March 2, 1936, elicited severe criticism—national and regional—from people who were offended by the Indian's savage treatment of naked white women. However, the program was, in general, very well received, and was considered, stylistically and compositionally, one of Mechau's most significant murals.

30

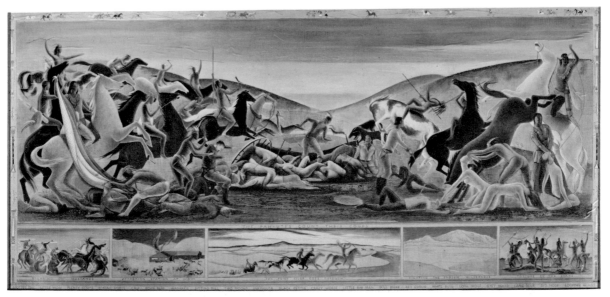

31

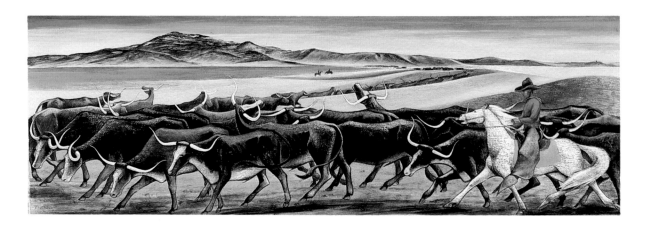

FRANK A. MECHAU (1904-1946)

32. Longhorn Drive

Oil on masonite, 13 × 40½ in.

Signed and inscribed (at lower left): Mechau/Redstone Colo

Painted in 1937

EXHIBITED: Amon Carter Museum of Western Art, Fort Worth, Texas, 1967, *Frank Mechau (1904-1946): A Retrospective Exhibition of Paintings and Drawings,* [n.p.][n.n.], as *Longhorns* // The Denver Art Museum, Colorado, 1972, *Frank Mechau Retrospective, 1904-1946,* pp. 11 illus., 17 no. 27 // Aspen Center for the Visual Arts, Colorado, and the University of Colorado Art Gallery, Boulder, 1981-82, *Frank Mechau, Artist of Colorado,* pp. 38 illus., 75 [n.n.]

EX COLL. estate of the artist, until 1984

In 1937 Mechau purchased property in the small village of Redstone, Colorado. One of the buildings he bought, the old Redstone firehouse, remained his studio until 1945. During this time, from 1937-38, Mechau taught painting at the Colorado Springs Fine Arts Center and worked up designs for murals. *Longhorn Drive,* executed in 1937 and inscribed "Redstone Colo," is a study for a mural in the Ogallala Post Office, Nebraska. A drawing for this painting is also in the Hirschl & Adler collection.

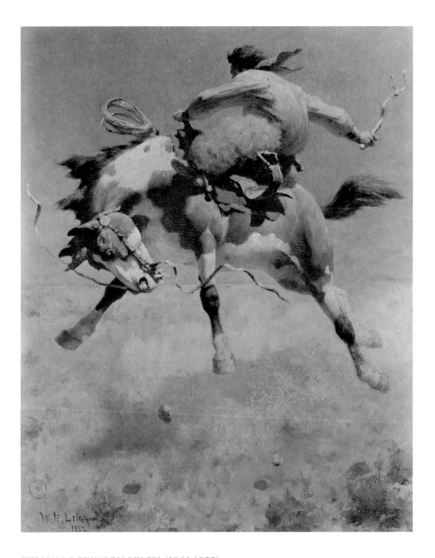

WILLIAM ROBINSON LEIGH (1866-1955)

33. Pulling Leather

Oil on canvas, 28⅛ × 22¼ in.

Signed, dated, and inscribed (at lower left):
©/W. R. LEIGH/1952

RECORDED: June DuBois, *W. R. Leigh: The Definitive
Illustrated Biography* (1977), p. 124 illus.

EX COLL: Rembrandt Peale, Jr., Greenwich, Connecticut,
a descendant of Charles Willson Peale and Rembrandt
Peale (purchased in 1950's in Arizona); by descent in the
family, until 1984

From Leigh's first trip to the Southwest in 1906 he
devoted himself almost exclusively to the depiction of
western scenes. Sometimes he painted expansive land-
scapes at sunset or the local Indian population engaged
in domestic activities; at othertimes, his work reflected
the exuberant life of the cowboys and ranchers there.

Typical of the latter type is *Pulling Leather.* The spirited
action of the bucking bronco suspended in air evokes
the wildness of the frontier, while the pastel colors
suggest the aridness of the desert.

INDEX